POSTCARD HISTORY SERIES

Quincy

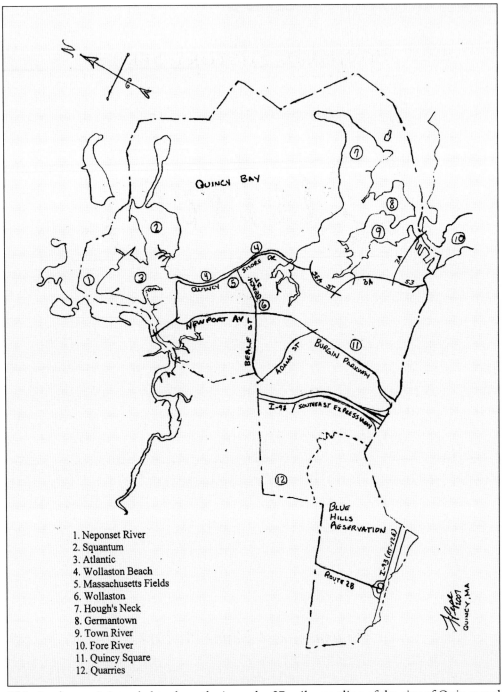

1. Neponset River
2. Squantum
3. Atlantic
4. Wollaston Beach
5. Massachusetts Fields
6. Wollaston
7. Hough's Neck
8. Germantown
9. Town River
10. Fore River
11. Quincy Square
12. Quarries

This simple map is intended to show the irregular 27-mile coastline of the city of Quincy and some of the major roads that cross the city. The circled numbers indicate the approximate location of some of the many neighborhoods or features that are mentioned in this book.

On the front cover: Please see page 93. (Author's collection.)
On the back cover: Please see page 62. (Author's collection.)

POSTCARD HISTORY SERIES

Quincy

William J. and Elaine A. Pepe

ARCADIA
PUBLISHING

Published by Arcadia Publishing
Charleston SC, Chicago IL, Portsmouth NH, San Francisco CA

Printed in the United States of America

Library of Congress Catalog Card Number: 2007931952

For all general information contact Arcadia Publishing at:
Telephone 843-853-2070
Fax 843-853-0044
E-mail sales@arcadiapublishing.com
For customer service and orders:
Toll-Free 1-888-313-2665

Visit us on the Internet at www.arcadiapublishing.com

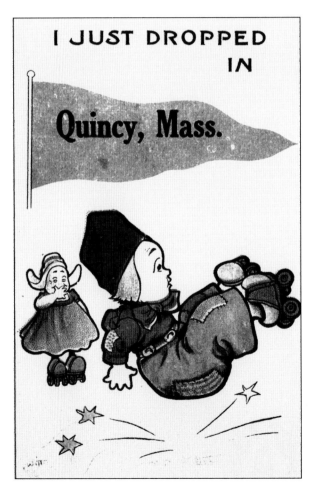

Tourists and summer residents helped the postcard industry flourish in Quincy. Not only were generic greetings popular, but they also reflected accepted humor of the era. Here a young lad "drops in" from his roller skates. The card, postmarked 1916, was manufactured in the United States. Before World War I many postcards were printed in Germany. Do the youths' costumes reflect American concern about the war then being waged in Europe?

CONTENTS

ACKNOWLEDGMENTS

We thank the following individuals who generously contributed their knowledge and advice to the preparation of this book: R. Peter Carlson, Mike Del Greco, Elizabeth Emde, Rev. William C. Harding of Bethany Church, Dan Lucas, Carmella Lo Presti, Mary Lyons, Bob Munroe, David Pepe, Franklin Pepe, Erin Stone of the Arcadia staff, David Smith, and John Tramontana.

We thank the following organizations that allowed us to use their resources and/or otherwise helped in the preparation of this book: the Adams National Historical Park, Quincy College, Quincy Historical Society, South Shore Historical Society, and the Thomas Crane Public Library.

If we have inadvertently forgotten to mention others who helped in the preparation of this book, we thank them also and apologize for not including their names.

INTRODUCTION

The history of Quincy's growth as a city starts in 1625. This book reflects on a portion of that history. The book reflects on that portion which is recorded on picture postcards of the 20th century, especially the early 20th century. There are over 2,000 known postcards that relate to the city of Quincy. This book contains images of about 220 of them.

In addition to postcards themselves, the postage stamps, the postmarks, and the messages found on postcards each record a piece of history. Each of these features has its own body of collectors who specialize in that particular feature.

The messages on some postcards tell that, from their inception, picture postcards were admired and collected by the public. In the early 20th century, cameras were not readily available, and those pretty picture postcards were to be treasured. (Does your favorite restaurant have old postcards framed on its walls?)

Some of the places we mention in this book are gone and would have been forgotten by the public if it were not for their image on a postcard. Other places are still in existence. Many of them are available to be enjoyed. They look forward to your visit.

We hope that you enjoy viewing the images and reading the text in this book. In addition to your enjoyment of this book, we hope the book stimulates your interest in local histories, especially the history of the city of Quincy.

Read and enjoy,
William and Elaine Pepe
August 2007

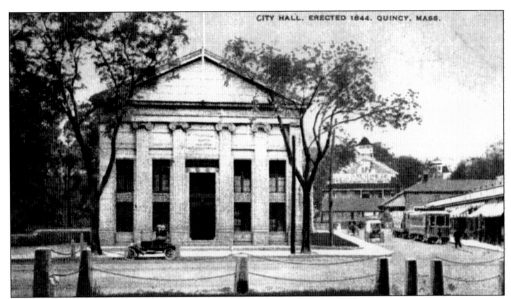

In 1844, Quincy still had a town form of government. The edifice illustrated above was built bearing the title "Town Hall" etched into its Quincy granite. Below that etching is a sign that indicates the building is now city hall. This *c.* 1910 image of city hall shows varying forms of transportation. To the right on Depot Street, which leads to Quincy Center's railroad station, notice pedestrian activity, a horse and buggy, an automobile, and trolley cars. The McIntyre Mall now occupies the site of Depot Street.

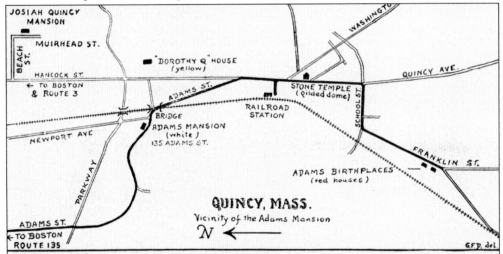

Near the Adams Mansion are—the red farmhouses, where the Presidents were born—the Stone Temple with gilded dome, containing their tombs—just over the bridge the "Dorothy Q. House"—and a mile toward Boston, Hancock Street, turning right at Beach to Muirhead Street, the old Col. Josiah Quincy Mansion.

ADAMS MEMORIAL SOCIETY
135 Adams St., Quincy, Mass.
Tel President 1177.

ADAMS MANSION
135 Adams St., Quincy, Mass.
Tel. President 1177

This postcard-sized advertisement dates from the late 1930s when the Adams Memorial Society was responsible for maintaining the Adams Mansion. It shows the relative locations of most of the buildings mentioned in chapter 1. The Adams Academy, built on the birth site of John Hancock and not mentioned on the card, would appear at the junction of Adams Street and Hancock Street.

One

CITY OF PRESIDENTS

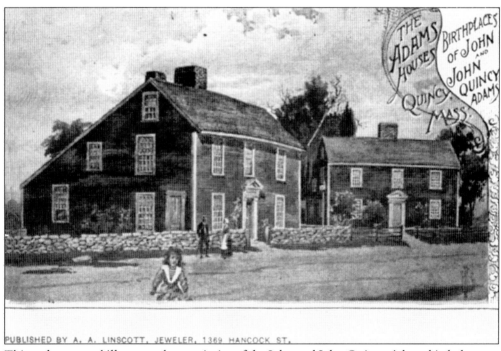

This early postcard illustrates the proximity of the John and John Quincy Adams birthplaces to each other. The publisher of this ornate card clearly gives his name and address on the picture side of the card. Before 1907, large white areas were left on the picture side of postcards because postal regulations restricted the other side to the address only. Legislation changed that after 1906. This postcard bears the postmark 1904.

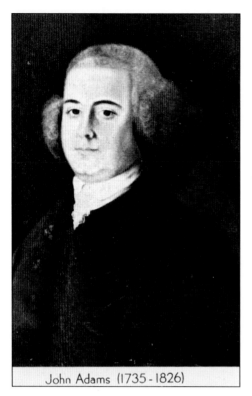

John Adams (1735 - 1826)

The two pastel portraits illustrated on this page were painted by Benjamin Blyth in 1764, the year of John and Abigail Adams's marriage. John was born in Quincy (then part of Braintree), was politically active throughout the Revolutionary War era and the Articles of Confederation era, and was elected second president under the Constitution. John died on July 4, 1826, the same day his sometimes friend and sometimes opponent Thomas Jefferson died.

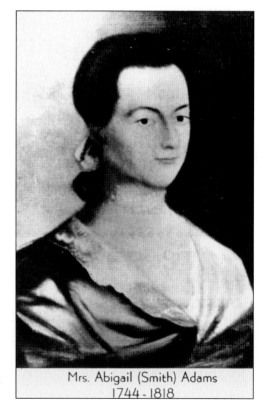

Mrs. Abigail (Smith) Adams
1744 - 1818

In 1764, Abigail Smith and John Adams were married at the home of Abigail's father, Rev. William Smith of neighboring Weymouth. John met Abigail when he called upon the Reverend Smith for instruction. Abigail's lively correspondence with John during his government service away from home earned Abigail a reputation as a learned lady. Their correspondence has been collected and published. Abigail died in 1818.

John Quincy Adams was born on July 12, 1767, to Abigail and John. The child was named in honor of his great-grandfather Col. John Quincy. In 1792, a breakaway portion of Braintree chose to name itself after the same Colonel Quincy. John Quincy went on to be the sixth president of the United States under the Constitution. The portrait illustrated on this postcard was painted by John Singleton Copley in 1795.

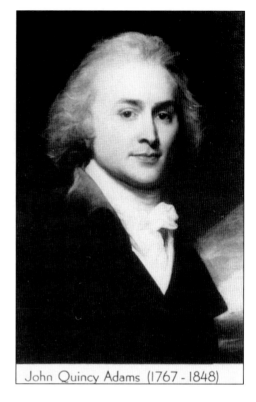

John Quincy Adams (1767 - 1848)

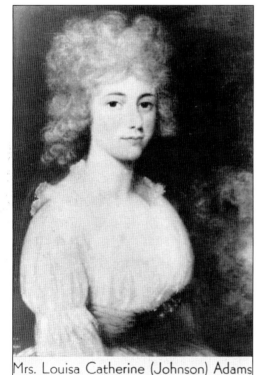

Mrs. Louisa Catherine (Johnson) Adams
1775 - 1852

Louisa Catherine Johnson was born in London on February 12, 1775, to an American father and an English mother. She and John Quincy married on July 26, 1797, against the wishes of Abigail Adams. Louisa's family life was marred by failed pregnancies and children who did not survive to adulthood. The 1797 portrait of Louisa illustrated here is believed to have been painted by American artist Mather Brown.

11

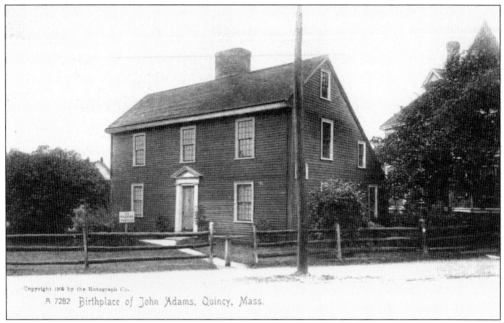

A 7282 Birthplace of John Adams, Quincy, Mass.

John Adams (born 1692) and his wife, Susannah Boylston (born 1699), purchased this home in 1720. Here their son, John Adams, who was destined to be a major contributor to the independence of the United States and its second president under the Constitution, was born in 1735. The large border on the bottom of the postcard helps identify the postcard as being of the "before 1907, undivided-back" variety.

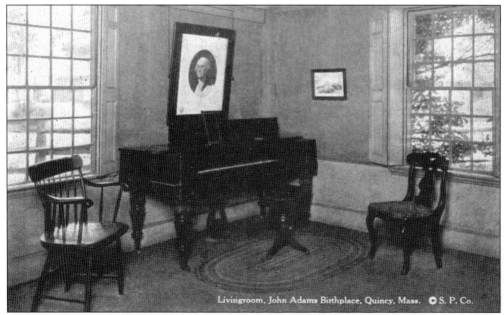

Livingroom, John Adams Birthplace, Quincy, Mass. © S. P. Co.

Interior views of prominent homes were popular in the first half of the 20th century. This postcard is one of a series giving the public views of the interior of the John Adams birthplace. This postcard shows the living room of that home. The Adams's birthplaces are only 75 feet apart. This postcard was published by the Adams Chapter of the Daughters of Revolution.

12

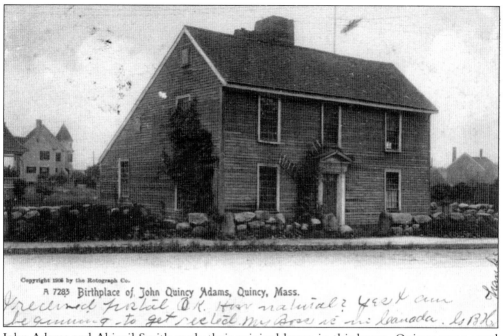

A 7283 Birthplace of John Quincy Adams, Quincy, Mass.

[handwritten postcard message, illegible]

John Adams and Abigail Smith made their original home in this house. Quincy was a rural community and part of Braintree at that time. John Quincy Adams, sixth president of the United States under the Constitution, was born here in 1767. It was from here that he, his sister, and his mother made their walk to the top of Penn's Hill to view the Battle of Bunker Hill.

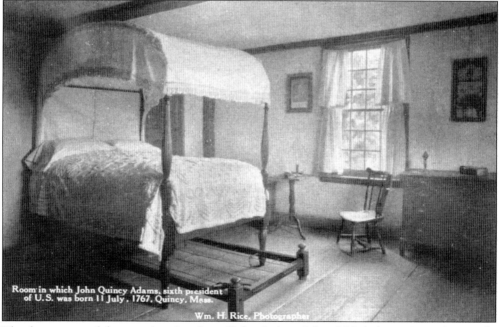

Room in which John Quincy Adams, sixth president of U.S. was born 11 July, 1767, Quincy, Mass.

Wm. H. Rice, Photographer

The above postcard shows an interior view of John Quincy Adams's birthplace. Notice the trundle bed. This postcard is a part of a series showing interior views of this birthplace. This series was published by the Quincy Historical Society. Both Adams birthplaces are on their original sites, and both are open to the public via guided tours by the Adams National Historical Park.

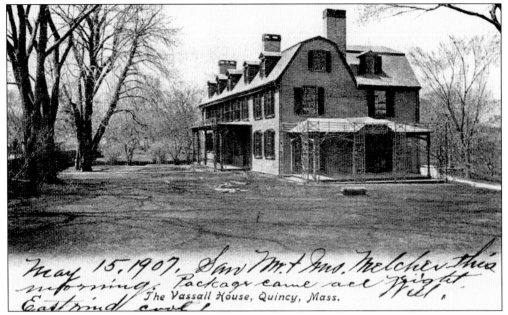

May 15, 1907, Saw Mr. & Mrs. Melcher this morning. Package came all right. East wind cool!

The Vassall House, Quincy, Mass.

Maj. Leonard Vassall built the original portion of this mansion in 1731. In 1787, John Adams purchased the home from Major Vassall's grandson and immediately expanded the home. Four generations of the Adams family occupied the mansion from 1788 to 1927. The Adams Memorial Society operated and maintained the property until they gave it to the federal government in 1946. The building can now be toured in season through the Adams National Historical Park.

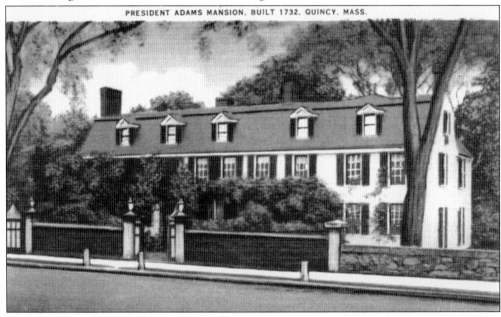

PRESIDENT ADAMS MANSION. BUILT 1732. QUINCY, MASS.

Use of an inexpensive paper gave a linen effect to some postcards printed from 1930 through 1945. Images on a "linen" postcard have an almost artificial style and hardly appear as a photograph. Although initially popular with the public, linen postcards did not gain popularity with collectors until the 1990s. Here is another view of the Adams Mansion. Notice the stone and brick wall and the hitching posts along the sidewalk.

A Partial Genealogical Listing of the First Edmund Quincy's Descendants

1st Edmund Quincy
c. 1602-1636
Acquired Wollaston land
|
2nd Edmund Quincy
1628-1698
Built the Dorothy Q. House

2nd Edmund's descendants by his 1st wife Joanna Hoar	2nd Edmund's descendants by his second wife Elizabeth Gookin
Daniel Quincy 1651-1690 m. Anna Shephard 1663-1708	3rd Edmund Quincy 1681-1738* m. Dorothy Flynt 1678-1737
John Quincy 1689-1767 The City of Quincy and the sixth US President named in his honor	1st Josiah Quincy 1710-1784 Built Josiah Quincy House
Elizabeth Quincy 1791-1775 Married Reverend William Smith	2nd Josiah Quincy 1744-1864 The Great Patriot
Abigail Smith 1744-1818 Married John Adams Second US President	3rd Josiah Quincy 1772-1864 The Great Mayor of Boston President of Harvard University
John Quincy Adams 1767-1848 Sixth US President	4th Josiah Quincy 1802-1882 Built Quincy Mansion c. 1850 which became a girl's school

*Other Descendants of the 3rd Edmund Quincy
and Dorothy Flynt
|
4th Edmund Quincy 1703-1788
m. Elizabeth Wendell
|
Dorothy Quincy 1747-1830
m. John Hancock 1737-1793
Seventh US President under
The Articles of Confederation

The genealogical chart above shows the relationships between the Quincy family members who were prominent in the formative years of the United States and who lived in and/or were responsible for the construction of some of the historic buildings shown in this chapter. The tendency of the Quincy family to repeat names is alleviated by showing birth and death dates and by the use of a numerical prefix.

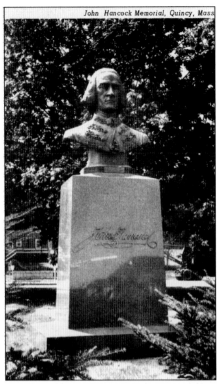

John Hancock was born in Quincy in 1737 and lived at what is now the site of the Adams Academy until he was seven. Hancock served as president of the Second Continental Congress in 1775 and was the first to sign, with his bold signature, the Declaration of Independence. He also served (1785–1786) as president of the United States under the Articles of Confederation. In 1775, he married Dorothy Quincy.

The Adams Academy is located on the site of the parsonage of the then Congregational church (now Unitarian Universalist). Rev. John Hancock was minister of that church when his son John, of Revolutionary War fame, was born. Sadly, Reverend Hancock passed away in 1744 and young John was raised and educated by his uncle Thomas Hancock. The memorial pictured at the top of this page is on the Adams Academy grounds.

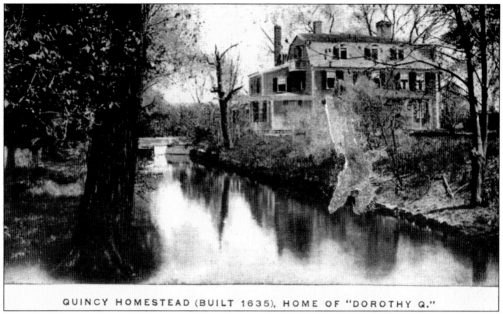

QUINCY HOMESTEAD (BUILT 1635), HOME OF "DOROTHY Q."

Dorothy Quincy, born in 1747, was raised here at the corner of Butler Road and Hancock Street. The house, built about 1686, was extensively renovated in 1706. Quincy planned to marry John Hancock here, but the Revolutionary War forced a change in the young lovers' plans. In 1904, the Colonial Dames of America purchased the home and entered a relationship with the Commonwealth of Massachusetts regarding its ownership and maintenance.

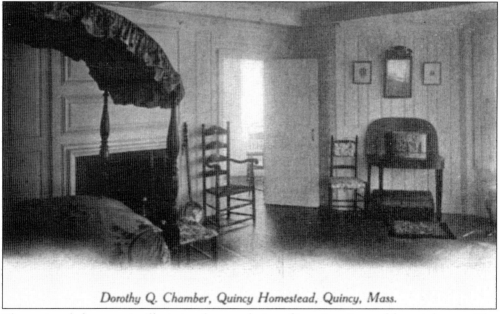

Dorothy Q. Chamber, Quincy Homestead, Quincy, Mass.

The postcard above again illustrates the popularity of interior views of famous homes. The image is pre-1907, identified by the white space at the bottom. The postcard is post-1907, identified by its divided back. Prior to 1907, one side of a postcard was to be used exclusively for the address. Divided backs, half for address, half for message, were permitted after the law changed late in 1906.

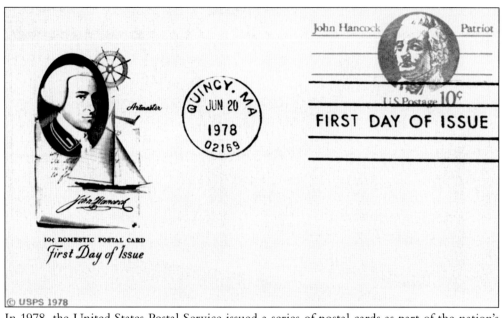

In 1978, the United States Postal Service issued a series of postal cards as part of the nation's bicentennial celebration. The preprinted stamp featured the portrait of a Revolutionary War patriot. One of the patriots so honored was Quincy-born John Hancock. The "first day of issue" postmark was assigned to Quincy. A postal card differs from a postcard in that a postal card is issued by a government agency.

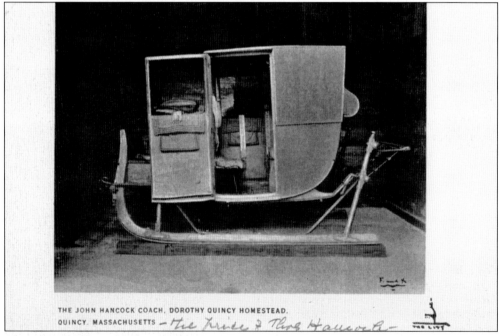

THE JOHN HANCOCK COACH, DOROTHY QUINCY HOMESTEAD. QUINCY. MASSACHUSETTS

An object of interest stored at the Dorothy Quincy house is Hancock's coach. Mounted on runners, it speaks of an era before snowplows, road salt, and sand. The postcard illustrated is unused and of the undivided-back variety with message space on the front. The notation on the bottom of card reads, "The pride of Thos Hancock." Thomas Hancock was the uncle who raised John.

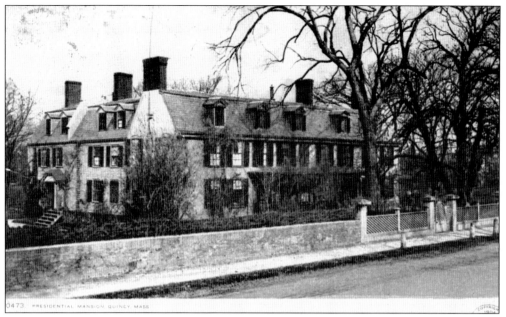

This postcard, copyright 1904 by Detroit Photographic Company, gives another view of the Adams Mansion, this time from the left side. Detroit Photographic Company was a publisher of postcards in the early 20th century. Its postcards are considered desirable by postcard collectors. The Library of Congress has this image and 25,000 other images from the now defunct Detroit Publishing Company (formerly the Detroit Photographic Company), many available online.

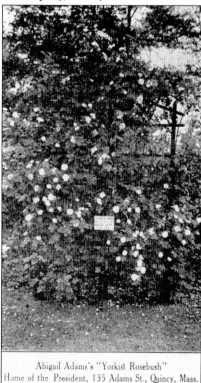

Abigail Adams's "Yorkist Rosebush"
Home of the President, 135 Adams St., Quincy, Mass.

With the same enthusiasm as any other housewife when moving to a new and larger home, Abigail Adams beautified her new home by planting this rosebush in 1788. This "Yorkist Rosebush" was imported from England and still can be seen by visitors to the Adams Mansion. The rosebush and the Adams Mansion are maintained by the Adams National Historical Park and are included in the tour of the park.

19

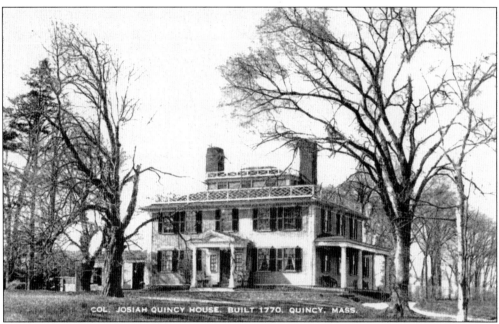

COL. JOSIAH QUINCY HOUSE. BUILT 1770. QUINCY. MASS.

Col. Josiah Quincy, the first of several prominent men of the same name, had this mansion built in 1770. From the upper monitor windows, Colonel Quincy observed the activities of the British fleet and reported these activities to George Washington. The house was occupied by Quincy descendants until the late 1800s. The Society for the Preservation of New England Antiquities conducts tours of the home on a limited schedule or by appointment.

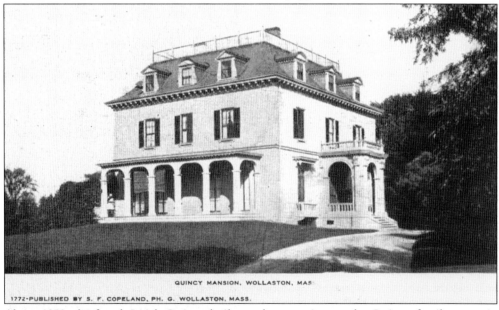

QUINCY MANSION, WOLLASTON, MAS

1772-PUBLISHED BY S. F. COPELAND, PH. G. WOLLASTON, MASS.

About 1850, the fourth Josiah Quincy built another mansion on the Quincy family estate in Wollaston. The mansion was converted to a girls' boarding school in the 1880s. The school had to compete with the free public high school. In 1919, Eastern Nazarene College purchased the school. The mansion was torn down in the late 1960s. Gardner Hall now occupies the 23 East Elm Avenue site.

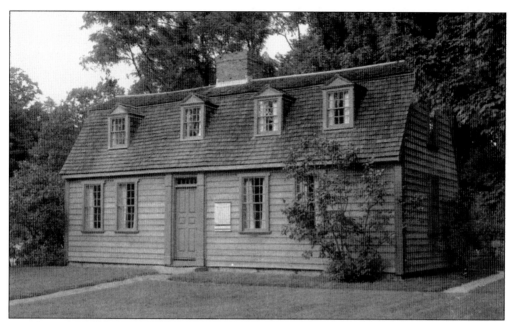

In 1744, Abigail Smith was born in this house in neighboring Weymouth. It was in this house that John Adams successfully courted and wed Abigail. Abigail was the granddaughter of Colonel Quincy in whose honor the city of Quincy was named. Informed that Colonel Quincy was dying, Abigail named her newborn son John Quincy Adams in honor of the colonel. The house is owned and maintained by the Abigail Adams Historical Society.

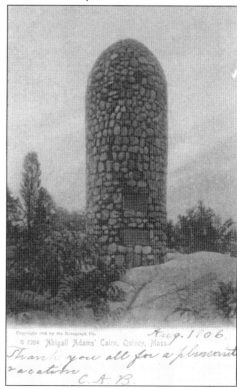

In 1775, Abigail took her son John Quincy and her daughter Abby to the top of nearby Penn's Hill. There they were able to view the smoke of the Battle of Bunker Hill. In honor of that event, the stone cairn illustrated was erected on June 17, 1896, by the Adams Chapter of the Society of the Daughters of the Revolution. The cairn is accessible to the public.

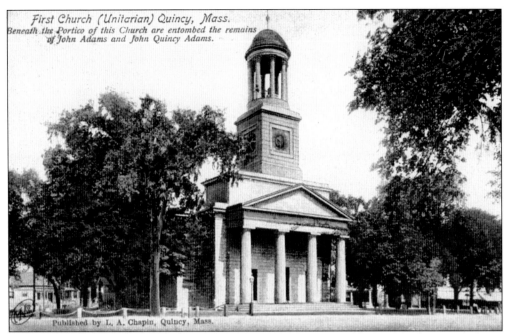

First Church (Unitarian) Quincy, Mass.
Beneath the Portico of this Church are entombed the remains of John Adams and John Quincy Adams.

Published by L. A. Chapin, Quincy, Mass.

John and Abigail Adams, their son John Quincy Adams, and his wife, Louisa Catherine Johnson, are encrypted in this church, which was so much a part of their lives. The United First Parish Church (Unitarian) was founded in 1639. Popular names for the church are the "Church of the Presidents," the "Stone Temple," and the "Old Stone Church." Tours of this church are available.

This undivided-back postcard shows a rare view of the back of the John Adams birthplace. The stump of a long-gone tree doubles as a fulcrum for lifting water out of a well. The slope of the rain gutter helps collects water in the rain barrel. The handwritten note on the side of the card says, "This house is furnished with the old fashioned furniture and is very interesting."

22

Boston Market, Boston, Mass.

Josiah Quincy, the mayor of Boston, hired Alexander Parris to design the Faneuil Marketplace, an extension of Faneuil Hall. Parris also designed the Church of the Presidents. The assembly room of the marketplace was to be known as the Quincy Room, but the name spread to encompass the entire building. Revitalized in 1976, Quincy Market is still an active part of Boston.

The third Josiah Quincy became known as the "Great Mayor" of Boston. It was he who was largely responsible for filling the marshlands between Faneuil Hall and Atlantic Avenue. It was during his term as mayor that the Faneuil Hall Marketplace was built; the popular marketplace is now known as Quincy Market. The Josiah Quincy statue illustrated was erected in 1879 and now stands in front of Boston's old city hall.

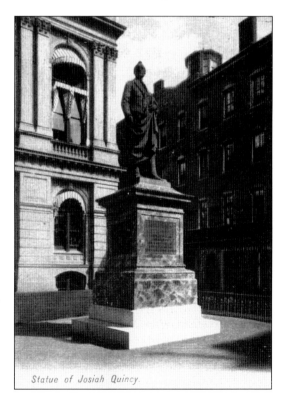

Statue of Josiah Quincy.

23

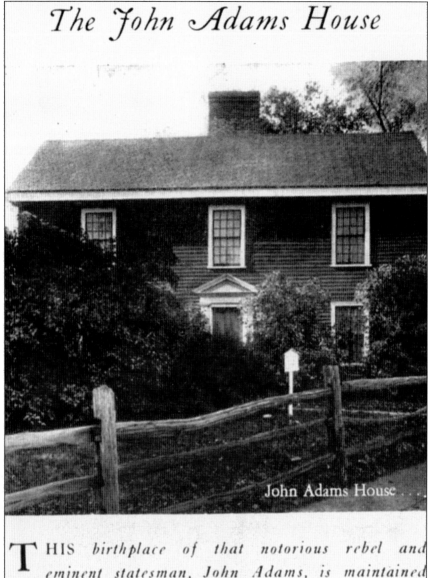

The John Adams House

John Adams House

THIS *birthplace of that notorious rebel and eminent statesman, John Adams, is maintained by the Daughters of the American Revolution. It is open for inspection and is located near the center of Quincy, a short drive from Filene's where the photo-mural from which this miniature was copied decorates the Restaurant.*

From the 1940s until the 1960s, Quincy was the giant retail shopping district for South Shore residents. Filene's, an old established department store, had an outlet that included a restaurant in Quincy's shopping center. The restaurant contained a photomural that was reproduced on this postcard. The card was distributed to the public to encourage visitors to the city and to encourage those visitors to shop at Filene's.

24

Two

GRANITE CITY

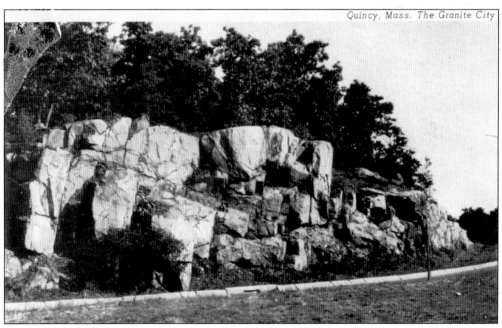

Quincy, Mass. The Granite City

A natural resource of Quincy is its granite. This card shows an outcropping of the granite along the side of a road. The earliest settlers of Quincy used granite boulders to build their first church and as a defense against the natives. From that early start, Quincy's granite became a major industry for the city, peaking in the 1890s. Today some of Quincy's granite quarries are part of the state park system and are available for recreational activities.

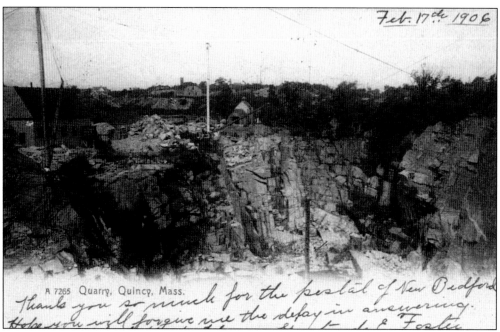

A 7265 Quarry, Quincy, Mass.

Feb. 17th 1906

Thanks you so much for the postal of New Bedford. Hope you will forgive me the delay in answering.

L. E. Foster

Postcards were in their infancy in 1906 when the sender of this card wrote, "I have about 160 postals now." Comments about postcard collections are commonplace on early postcards. Today many people still save the picture postcards that come to their home. The image above is an early scene from a Quincy quarry. A derrick used to lift the granite is prominent at the left border.

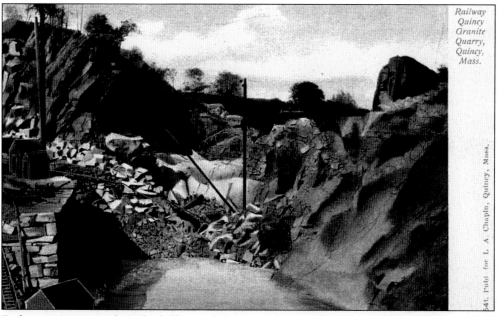

Railway Quincy Granite Quarry, Quincy, Mass.

541. Publ for L. A. Chapin, Quincy, Mass.

Early quarries were relatively shallow and did not encounter flooding problems. This pre-1907 postcard illustrates the problem of flooding that plagued the quarries as they became deeper. Continuous pumping was required to keep the quarries workable. The last working quarry closed in 1963. When the quarries were eventually abandoned, the flooding created popular swimming and diving holes for the youth of the neighborhood, but the quarries were extremely hazardous.

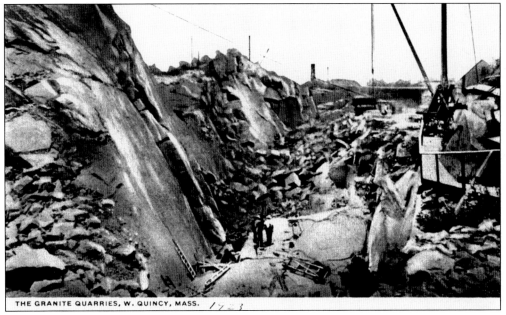

THE GRANITE QUARRIES, W. QUINCY, MASS. /ツ⌒3

Derricks were used to lift granite from the depths of the quarry (sometimes as much as 300 feet) and to move the commercial-grade granite blocks and the waste granite (grout) around the surface. The piles of grout were hazardous in their own way. The derricks were used as a form of elevator, carrying the workmen to the bottom of the quarry in open "boats."

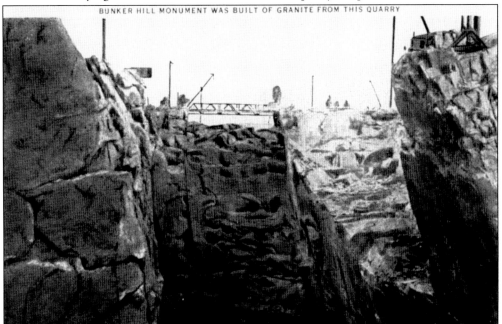

BUNKER HILL MONUMENT WAS BUILT OF GRANITE FROM THIS QUARRY

The occupation of quarrying was hazardous but so were the abandoned quarries. The City of Quincy and the Commonwealth of Massachusetts worked together to convert these hazards to safe use. Residential construction and a golf course have been built on some of their sites. The Metropolitan District Commission created Quincy Quarries Historic Site, where the popular activities of sightseeing, hiking, rock climbing, and picnicking are available to the public.

27

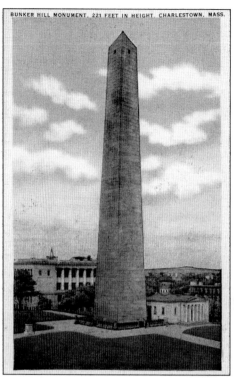

The desire to construct a monument to the Battle of Bunker Hill was the impetus that led to major efforts to quarry Quincy granite. Solomon Willard was the architect and construction supervisor who made the Bunker Hill Memorial become a reality. Willard determined that Quincy granite was the material best suited for the memorial's construction. Construction of the monument began in 1827 and, with many delays, was completed in 1843.

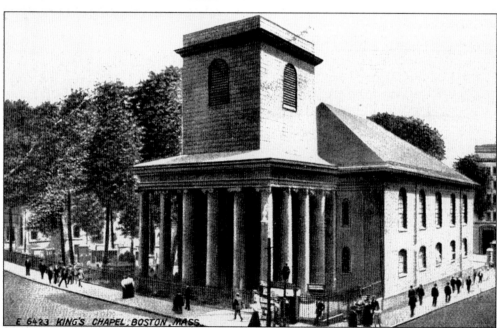

An early project constructed of Quincy Granite is King's Chapel, Boston. Organized in 1686, the congregation's small wooden church stood at the corner of School and Tremont Streets. The chapel's new granite building was constructed from 1749 to 1754 on the site of the original church building and is still in use. The funeral of Joseph Warren, who died in the Battle of Bunker Hill, was conducted from this church.

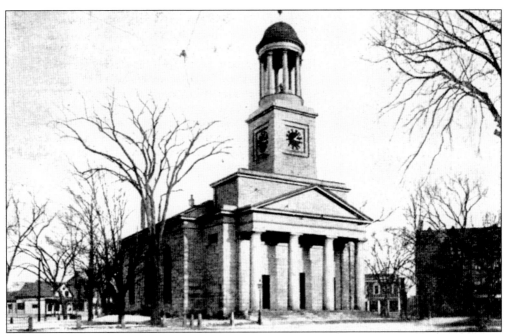

Directly across the street from Quincy City Hall is the United First Parish Church (Unitarian). Among the church's several unofficial names is the Stone Temple. Quincy granite was prominently used in its construction. John Adams donated much of the resources needed to obtain the granite. The four 25-foot-tall, 25-ton columns from Quincy's quarries were put in place in 1828 without the aid of power equipment.

Thomas Crane Library. Quincy, Mass.

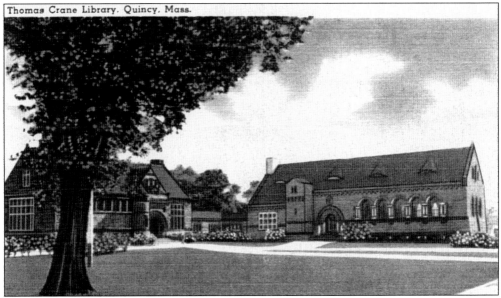

In 1880, Albert Crane donated $20,000 to erect a memorial library to his father, Thomas Crane. In 1882, the library was dedicated. Quincy granite was used as the library's base. Granite from Easton, Massachusetts, formed the walls. Brownstone was used for the trim. This postcard shows the original library on the left and the 1936 wing on the right. The 1908 Aiken wing is hidden behind the original building.

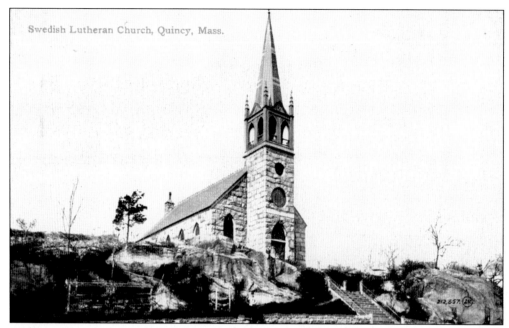

Swedish Lutheran Church, Quincy, Mass.

Another often portrayed building made of Quincy granite is the Swedish Lutheran Church on Granite Street. The membership of the church chose, in 1891, to purchase land on Granite Street that was nothing more than an outcropping of granite ledge. When the church was completed in 1894, it became an impressive edifice and was frequently the subject of scenic Quincy postcards.

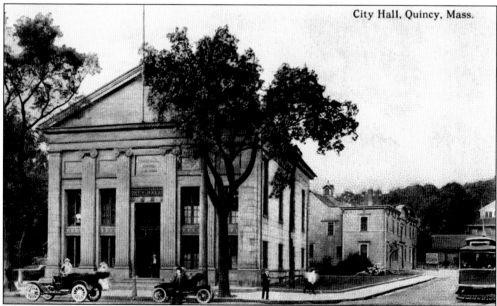

City Hall, Quincy, Mass.

In 1844, Quincy utilized local granite to build a new town hall (the current city hall). The architect was Solomon Willard. For ornamentation, Willard incorporated four pilasters into the design of the town hall. The end result was a building noted for being both utilitarian and beautiful. Now more than 150 years after its construction, it still serves the community, albeit with a major addition completed in 1979.

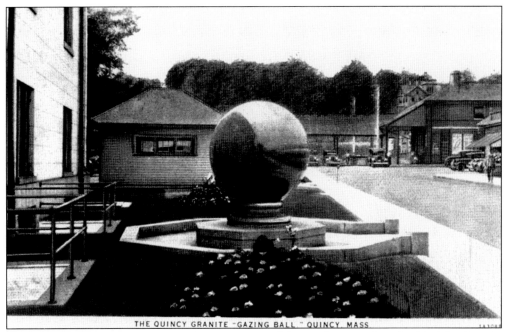

THE QUINCY GRANITE "GAZING BALL," QUINCY, MASS.

In 1925, to commemorate the 300th anniversary of the city's original settlement, the Granite Manufacturers Association of Quincy donated a nine-and-a-half-ton granite ball to the city. The granite had been quarried and donated from Swingle's quarries. The ball stood next to city hall for 12 years. The granite ball appeared in *Ripley's Believe It or Not* as the "most nearly perfect sphere in the world."

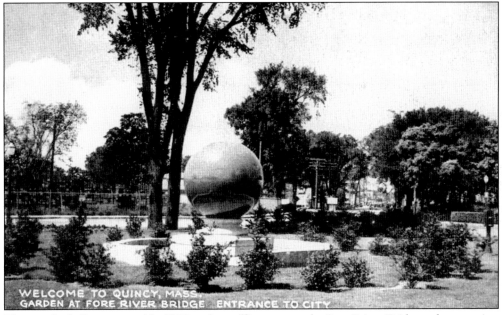

WELCOME TO QUINCY, MASS.
GARDEN AT FORE RIVER BRIDGE ENTRANCE TO CITY

The granite ball was moved in 1937 to the traffic rotary at the Fore River Bridge, where passing motorists could glimpse it but not see it closely. In 2006, the granite ball was repolished and returned next to city hall on the McIntyre Mall where pedestrian traffic can examine it closely. McIntyre Mall is located on what used to be Depot Street.

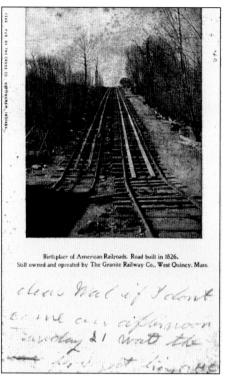

This undivided-back postcard of the Granite Railway's 84-foot inclined plane clearly shows the endless chain that helped control the descent of the railcars. The railcars were not powered by steam engines, as one would imagine. The railcars were powered first by horse and later by motor vehicles. This site is accessible from Mullin Avenue. The postmark is illegible.

Birthplace of American Railroads. Road built in 1826.
Still owned and operated by The Granite Railway Co., West Quincy, Mass.

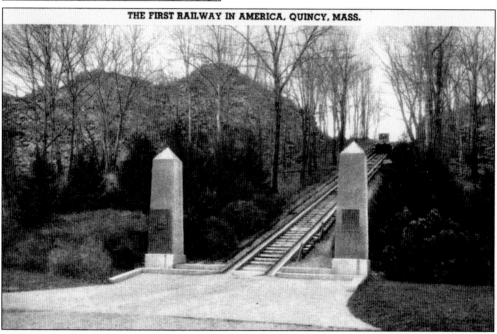

The Granite Railway was started in 1826 in order to move sufficient granite to the site of the Bunker Hill monument. The 85-foot controlled incline of the Granite Railway was built in 1830. It allowed the relatively safe lowering of granite to the main railway level. Nevertheless, the first known fatal railway accident in the United States occurred on this slope. The incline remained in operation for over 100 years.

32

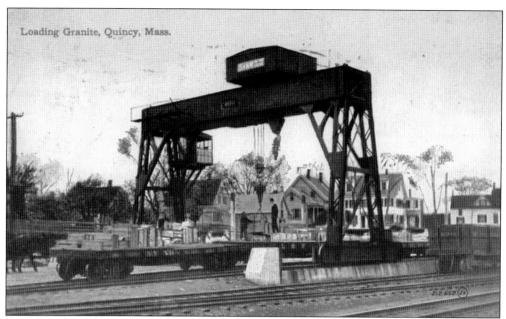

Loading Granite, Quincy, Mass.

This full photograph card, postmarked 1911, shows a more modern method of moving granite. An overhead crane is being used to load a flatbed railroad car with granite for shipment elsewhere in the United States. Quincy granite was used to build custom houses as near as Boston and as far as New Orleans. In 1860, Quincy granite was utilized in building the Stock Exchange Building in New York City.

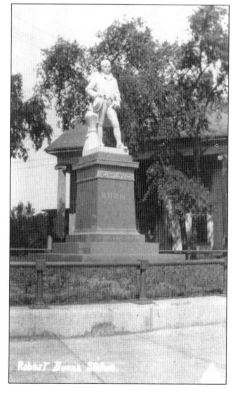

Among the immigrants from many nations who came to Quincy to work in the granite quarries was a significant number of Scottish. In 1926, as a part of the celebration of the city's 300th anniversary of its founding, the Scottish community donated to the city a statue of the Scottish poet laureate Robert Burns. The statue now stands at the corner of Burgin Parkway and Granite Street.

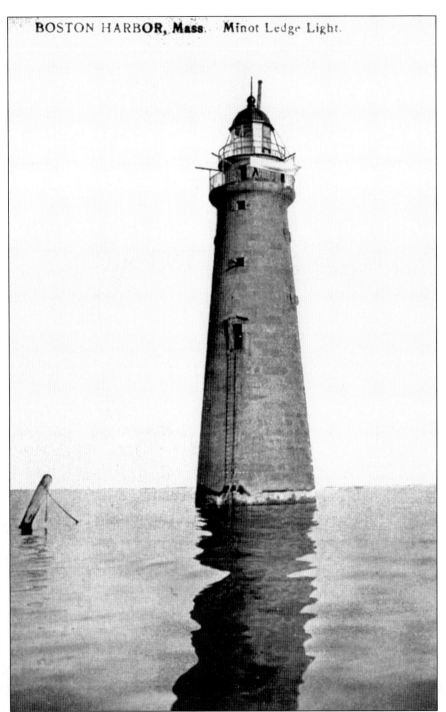

In order to avoid a repeat of the 1851 fatal collapse of the first Minot's Ledge Lighthouse, a more substantial lighthouse was built on Minot's Ledge. The material chosen for construction was Quincy granite. It took five years, 1855 to 1860, to construct the lighthouse, the first 40 feet of which is solid granite. The lighthouse's one-four-three signal has given the lighthouse the nickname the "I love you" lighthouse.

Three

WATERFRONT

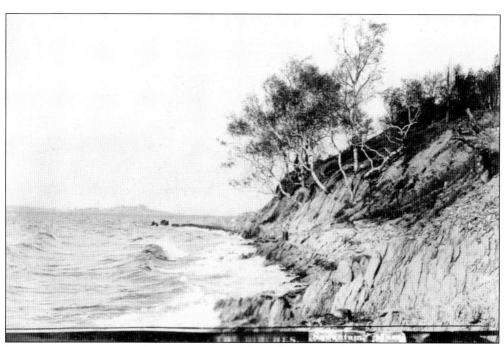

The popularity of Quincy's 27 miles of waterfront has obscured primitive scenes like the one shown above unless viewing from the water. This real-photo postcard shows white birch trees clinging precariously to a seaside slope that is exposed to the action of the harbor waters. The real-photo postcard was commonly used in the early part of the 20th century. This scene is from the Squantum section of Quincy. Squantum is a predominantly residential peninsula in the northern part of Quincy.

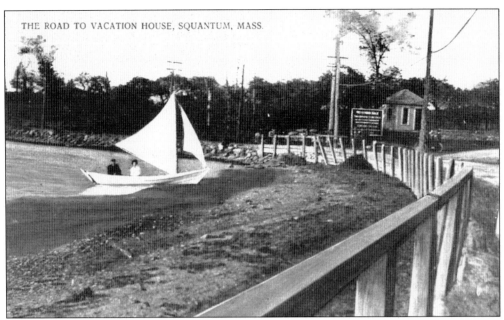

This idyllic scene depicts the proximity of Dorchester Street in Squantum to the ocean. Until the 1950s, a storm and/or high tide could cut off roadway traffic between Squantum and the mainland. Because of the quality produced by German printing shops, most postcards, including this one, were printed in Germany until World War I. This postcard's divided back indicates publication after 1906, narrowing its publication date to 1907–1914. The photograph could be noticeably earlier.

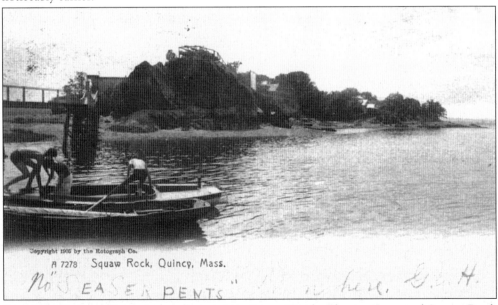

Copyright 1905 by the Rotograph Co.

A 7278 Squaw Rock, Quincy, Mass.

Some young men enjoy a day on the water at Squaw Rock. The area is named Squaw Rock because some see a silhouette of a native woman's face in a rock formation. Squaw Rock is now encompassed by a 17-acre town park located at the tip of the Squantum peninsula. The park features hiking trails, scenic beauty, 570 million-year-old rocks, ocean views, and the Myles Standish Cairn.

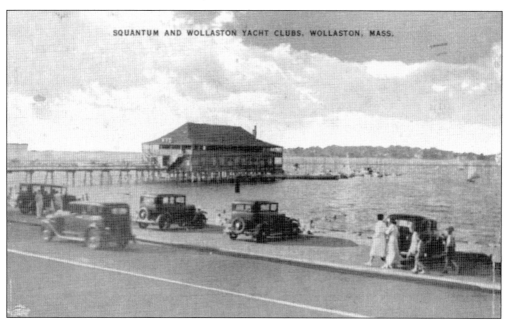

SQUANTUM AND WOLLASTON YACHT CLUBS, WOLLASTON, MASS.

This pair of glossy postcards shows automobiles parked at Wollaston Beach. People are seated on the beach, and others are in the water. The lack of the manufacturer's familiarity with the scenes being printed shows in this pair of 1930s postcards. The legend on the upper card indicates that there should be two yacht clubs in the image, but there is only one. The legend on the lower card has been corrected by overprinting with a silvery band and a more appropriate title. Hence the merchandise has been salvaged. (Below, courtesy Mike Del Greco.)

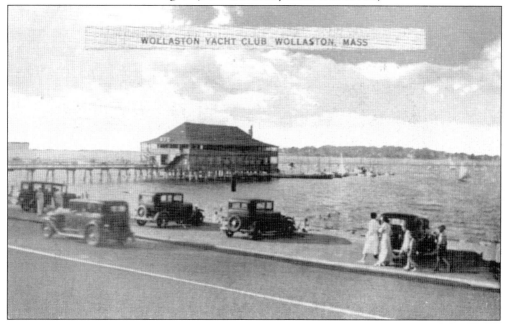

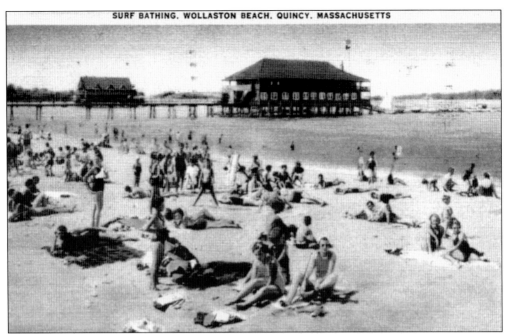

SURF BATHING. WOLLASTON BEACH. QUINCY. MASSACHUSETTS

Wollaston Beach runs more than two miles along the shore of Quincy Bay. It has been popular with beachgoers for generations. Postcards showing beach scenes are commonplace. Many carry simple messages such as "Wish you were here" or "I'll be home soon." The lure of the postcard is not only its picture but also its message, postage, and postmark. This card, postmarked 1942, carries the patriotic Statue of Liberty 1¢ stamp.

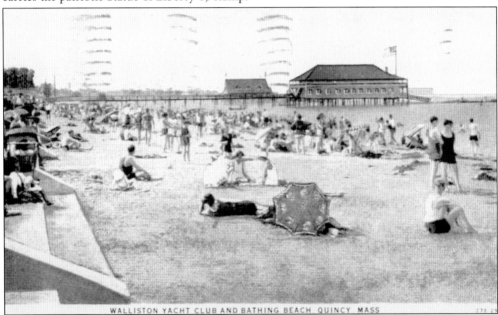

WALLISTON YACHT CLUB AND BATHING BEACH QUINCY MASS

This is another view of Wollaston Beach looking north. The bathers look quaint and conservative in the bathing suits of the era. Although the postmark on the card reads 1931, the image is from the 1920s when even the men were not allowed to be topless on the beach. Notice the misspelling of the word Wollaston.

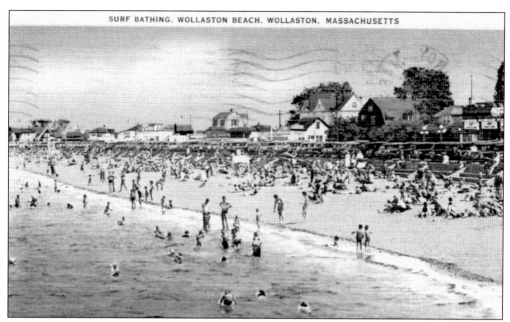

SURF BATHING, WOLLASTON BEACH, WOLLASTON, MASSACHUSETTS

This view of Wollaston Beach looking south shows the crowds that flocked to the beaches on a warm day. Although Wollaston Beach was readily accessible by public transportation, the automobiles that line the beach forewarn of heavy traffic in the years to come. The road that runs along the beach not only provides access to the beach but is also a major commuter road to Boston.

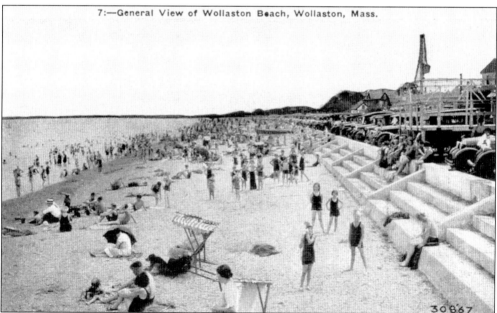

7:—General View of Wollaston Beach, Wollaston, Mass.

The stepped seawall dominates this Wollaston Beach photograph. Seawalls have come and gone over the years, but the ocean remains. Quincy Shore Drive (also known as Wollaston Boulevard) and adjacent properties are protected by the long seawall. Occasionally the ocean overruns the wall, but not frequently anymore. The photograph is from the late 1920s. Notice the four children posing to have their image preserved for posterity.

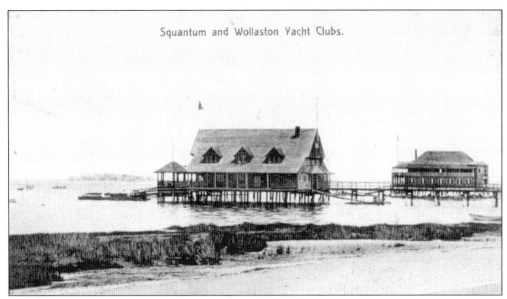

Squantum and Wollaston Yacht Clubs.

Family-oriented Squantum Yacht Club (SYC) was organized in 1890. This postcard shows SYC's original clubhouse. Wollaston Yacht Club is in the background. The "legs" of the clubhouses accommodate the flow of the tide. Despite the fact that this postcard was signed "with love," the writer laments about the poor penmanship used by the recipient when the recipient had sent the writer a card. This card is postmarked 1909.

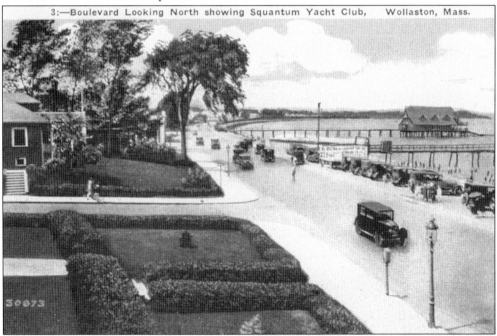

3:—Boulevard Looking North showing Squantum Yacht Club, Wollaston, Mass.

This 1920 scene shows automobiles on Quincy Shore Drive. There are numerous traffic lights now to protect the pedestrians and motorists. A magnificent ocean view is available from this busy roadway, but the motorist will have to park the car in order to have the time to appreciate the view. Massachusetts is constantly striving to improve the parking facilities along this road in order to allow the public to enjoy the waterfront.

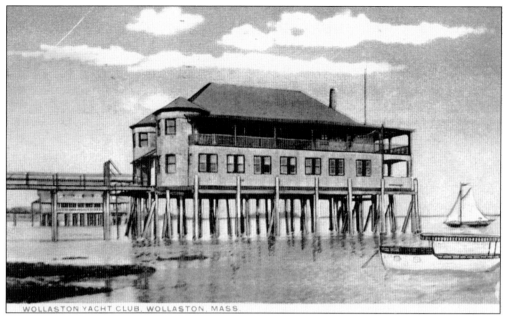

WOLLASTON YACHT CLUB, WOLLASTON, MASS.

The bylaws of the Wollaston Yacht Club (WYC) state that the club's goal is to encourage member participation in water activities. WYC is located on Quincy Bay near the SYC. Both clubs have land access from Quincy Shore Drive. The card pictured above, postmarked 1917, shows the old WYC clubhouse. A lesser quality of printing dominated the manufacture of postcards after World War I. White borders were added to save ink.

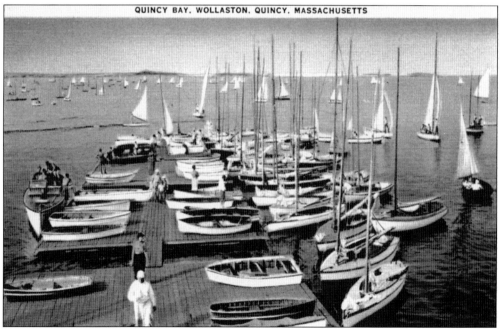

QUINCY BAY, WOLLASTON, QUINCY, MASSACHUSETTS

Skiffs rest on the pier of one of the yacht clubs. A lone mahogany launch graces the left side of the pier. Sailboats line the right side. The quantity of boats under sail on the bay indicates that it is either Quincy Bay Race Week or the sailors are practicing for race week. Quincy Bay Race Week has been held in July each year for almost 70 years.

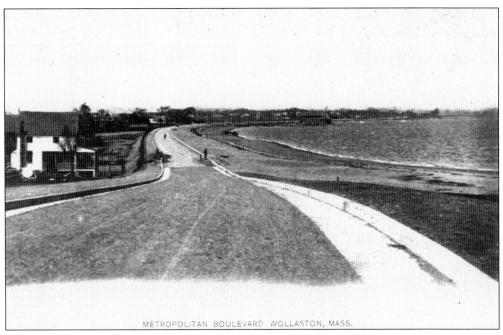

METROPOLITAN BOULEVARD WOLLASTON, MASS.

This *c.* 1905 view of Quincy Shore Drive shows a dip in the roadway bringing the roadway almost to sea level. High tides and storms would close and do damage to the road. Over the years, the roadbed has been raised and seawalls have been erected to protect the land and the public. Wollaston Beach is under the care of the Massachusetts Department of Conservation and Recreation.

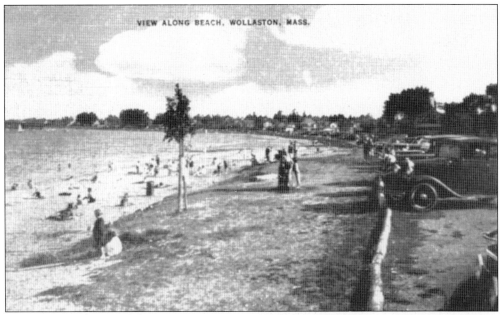

VIEW ALONG BEACH, WOLLASTON, MASS.

Photochrome, or glossy photograph, postcards made their initial appearance in 1939. This card, postmarked 1940, is one such example. Notice the log employed as a restraint for parked vehicles. Notice the lack of a seawall. Many improvements have been made for the safety of the public and to encourage public use of Wollaston Beach.

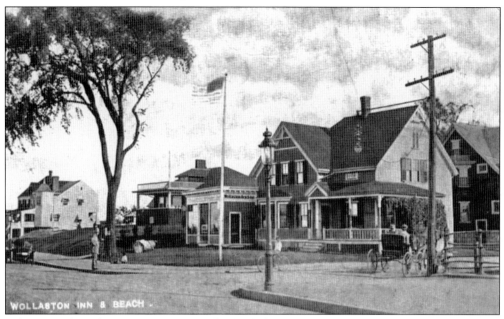

WOLLASTON INN & BEACH

When people gather, can a restaurant be far behind? This early-20th-century restaurant is across the street from Wollaston Beach. Notice the early automobile parked on the boulevard and the policeman in his "bobby" hat talking to the children. Is that a horse and buggy on the side street? There are still several restaurants across the street from the beach. This card is postmarked 1916.

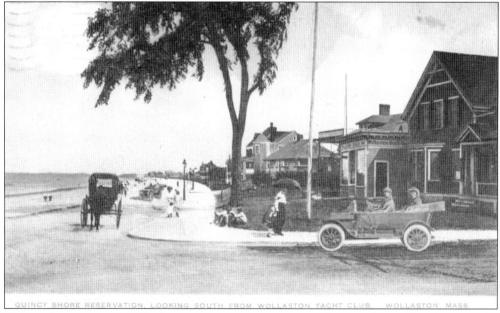

QUINCY SHORE RESERVATION, LOOKING SOUTH FROM WOLLASTON YACHT CLUB. WOLLASTON, MASS.

This card, postmarked 1919, shows the same street corner as the card above. The sign over the main door of the restaurant reads, "Wollaston Beach Inn." The two automobiles in the image were probably superimposed on the original photograph in order to "modernize" the card. Images for postcards were used, reused, and modified to maintain sales levels. The white border helps identify the card as post-1914.

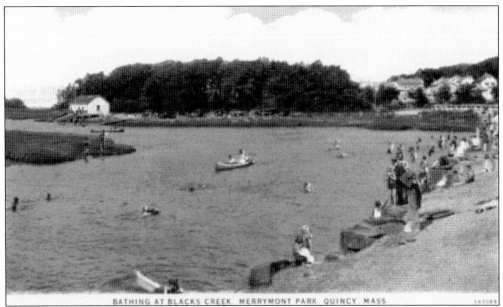

BATHING AT BLACKS CREEK, MERRYMONT PARK, QUINCY, MASS.

At the south end of Wollaston Beach is Black's Creek. This tidal creek has been used for various recreational purposes over the years. Caddy Memorial Park and the Reuben and Lizzie Grossman Memorial Park conserve its shores. The two parks provide scenic views, nature trails, and shelter for small wildlife. Bird watching and just plain relaxing are popular here. Caddy Memorial Park has picnicking facilities.

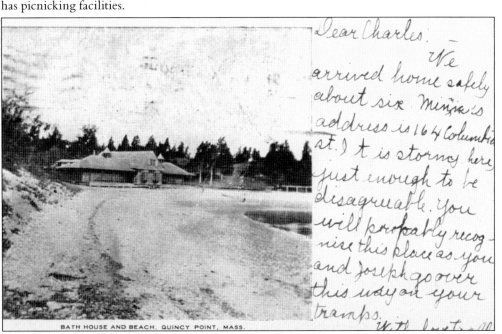

BATH HOUSE AND BEACH, QUINCY POINT, MASS.

Quincy Shore Drive is heavily traveled by commuters, and therefore, Wollaston Beach is well known to the motoring public. The city of Quincy, however, has a multitude of less-well-known and smaller beaches along its 27 miles of waterfront. This card, of the undivided-back variety and postmarked 1906, gives an early-20th-century view of one of the beaches along Quincy Point's Town River shoreline.

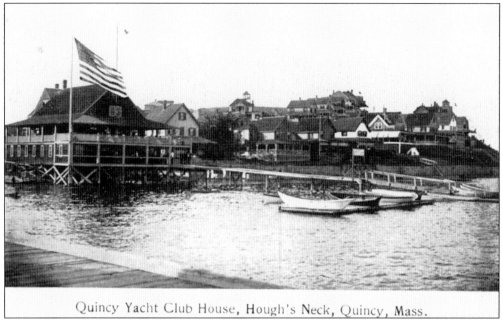

Quincy Yacht Club House, Hough's Neck, Quincy, Mass.

The 48-star flag flying in front of the original building of Quincy Yacht Club indicates that the image on this postcard was taken after the admission of New Mexico and Arizona to statehood in 1912. The observatory can be seen on the top of Great Hill. The water tower, built in 1914, is not yet erected. Neither the water tower nor the observatory remain. (Courtesy of Mike Del Greco.)

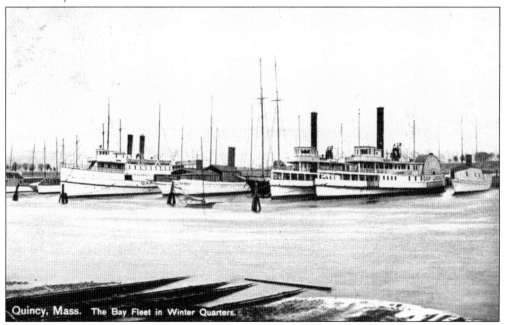

Quincy, Mass. The Bay Fleet in Winter Quarters.

Those steamboats that, in summer, connected the city of Boston to vacation spots such as Quincy, Weymouth, the Boston Harbor Islands, Nantasket Beach, and other Boston Harbor destinations needed a protected place to stay in the winter. In the image above, the *General Lincoln* and other Bay Line "steamers" are in winter storage along a sheltered river shore in Quincy.

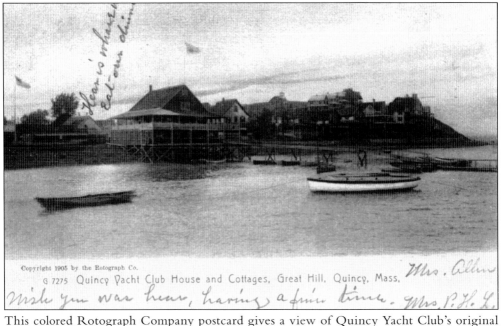

G 7275 Quincy Yacht Club House and Cottages, Great Hill, Quincy, Mass.

This colored Rotograph Company postcard gives a view of Quincy Yacht Club's original building, which was built in 1888 at the foot of Great Hill on the Hough's Neck peninsula. The same photograph, with and without color, may be found on Rotograph Company postcards. Rotographs were printed in Germany and are prized by today's postcard collectors. The yacht club was founded in 1874. This particular card is postmarked 1907.

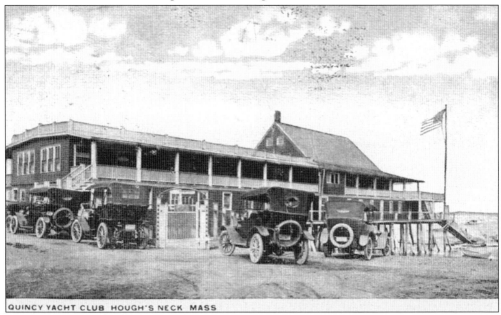

QUINCY YACHT CLUB HOUGH'S NECK MASS

In 1912, the original Quincy Yacht Club building was moved closer to the water and a major addition was added to accommodate its growing membership. This card, postmarked 1917, shows the addition clearly. World War I had put an end to postcards being printed in Germany, and a lesser quality of card was being mass-produced in the United States. The white border had been added to save the printer's ink.

46

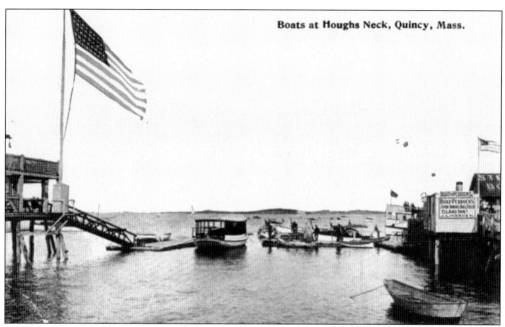

Boats at Houghs Neck, Quincy, Mass.

A steamboat is tied up at Harvey's Wharf, which, in this image, stands to the right of Quincy Yacht Club. This full photograph (no white border) postcard is dated 1914. At one time, Boston Harbor was the "flounder fishing capital of the world," and Quincy's waterfront thrived. Pollution in Boston Harbor dramatically reduced sportfishing. Boston Harbor cleanup efforts are succeeding, and flounder and other fish are returning.

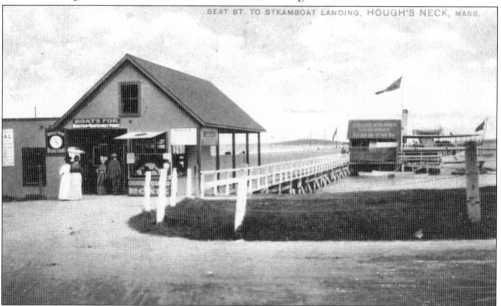

SEAT ST. TO STEAMBOAT LANDING, HOUGH'S NECK, MASS.

Hough's Neck was a popular vacation spot for Bostonians whether they were visiting for a day, a week, or the season. The clock on the left indicates that the next boat to Boston leaves at 4:00 p.m. The shanty roof says, "Direct Steamer to & from Boston." A steamboat is tied at the end of the pier. Daily steamboats connected Bostonians with Hough's Neck. Notice the attire of the boarding passengers.

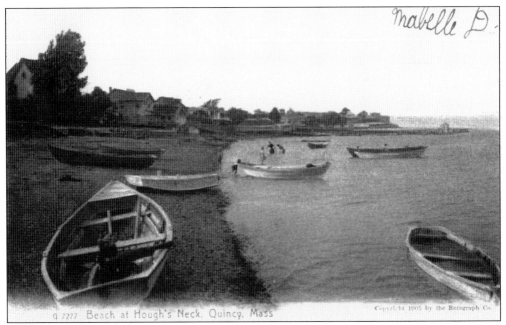

mabelle D.

G 7277 Beach at Hough's Neck. Quincy. Mass Copyright 1905 by the Rotograph Co

This copyright 1905 view of a beach in Hough's Neck shows a bevy of the smaller boats that were popular with the flounder fishermen who frequented Boston Harbor waters. In the distance, one can barely discern the Nut Island sewage treatment plant. Wastewater discharged from this plant into Quincy Bay reduced the quantity and quality of the flounder to be caught. Quincy Bay is rapidly recovering from this environmental disaster.

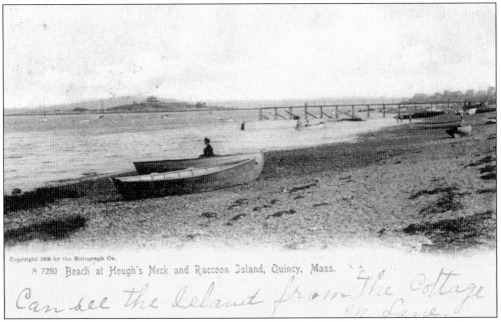

Copyright 1906 by the Rotograph Co.
A 7280 Beach at Hough's Neck and Raccoon Island, Quincy, Mass.

Can see the Island from the Cottage in line.

Another 1905 rotograph postcard from the same series as above shows a lady enjoying the view at low tide. The flounder fishing boats are secured and will not float away on the next high tide. The Quincy Yacht Club pier stands high above the water level awaiting the change of tides. Just offshore, Raccoon Island, now unoccupied, still had a house standing upon it.

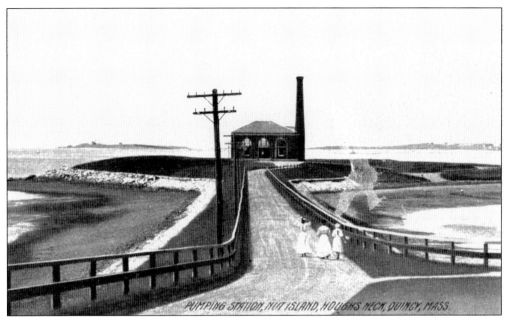

For over 100 years, the Nut Island facilities poured wastewater into Boston Harbor. The problem now has been alleviated. Although the island still has facilities that aid in the treatment of sewerage, wastewater is no longer emptied into Boston Harbor. The island has been incorporated into Boston Harbor Islands National Recreation Area and is accessible by automobile. A man-made pier accommodates shore fishing.

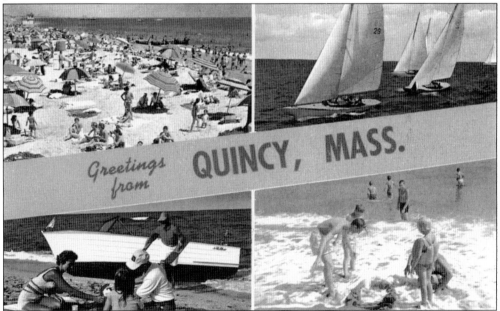

This 1960s glossy postcard extols the recreational virtues of Quincy's 27 miles of waterfront. The card shows a crowded, sunny day at the beach, sailboats on the bay, picnicking from a powerboat, and a family making sand castles at the water's edge. What could be more tempting? Multiple-image postcards have been popular since the earliest days of postcards. (Courtesy Mike Del Greco.)

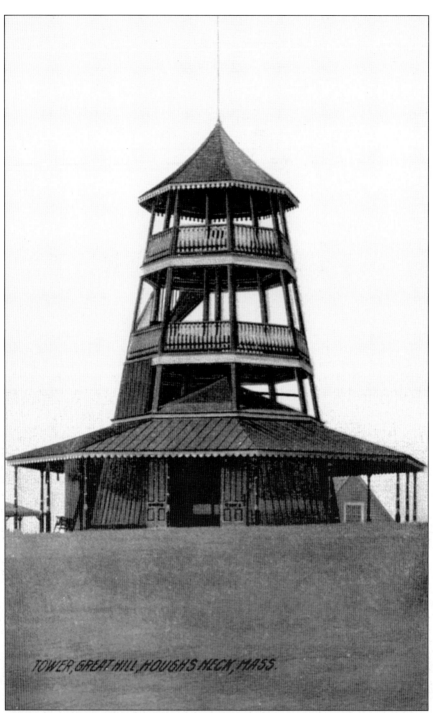

TOWER, GREAT HILL, HOUGHS NECK, MASS.

About the advent of the 20th century, a six-sided observatory was erected on the top of Great Hill. For a small fee, one could climb the stairs to the top of this observatory in Hough's Neck and enjoy the view. The view included Boston Harbor, the Boston skyline, the Blue Hills, and the Nantasket peninsula. In 1914, a water tower was erected next to the observatory. Both are now gone. (Courtesy Mike Del Greco.)

Four

FORE RIVER

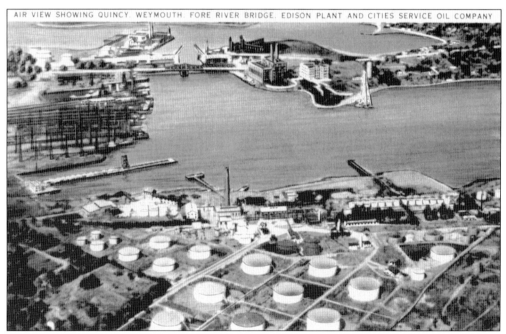

AIR VIEW SHOWING QUINCY, WEYMOUTH, FORE RIVER BRIDGE, EDISON PLANT AND CITIES SERVICE OIL COMPANY

This postcard shows the junction of three communities, Quincy on the left, Braintree in the center foreground, and Weymouth on the right. The river shared by the three seaport towns is the Fore River. The Fore River Shipyard dominates the Quincy shoreline. The former Proctor Gamble plant is beyond. The Cities Service oil storage tanks are in Braintree. The Boston Edison's Edgar Station is in Weymouth. In this image, the 1902–1935 iron bridge still spans the river while the 1935–2004 bridge approaches completion.

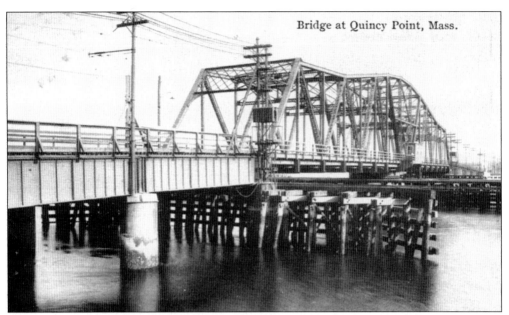

Bridge at Quincy Point, Mass.

Thomas Watson (of telephone fame) moved his boat and engine building facility from the Braintree shore of the Fore River downstream to a Quincy shore. He convinced the state to finance a new bridge over the Fore River and then convinced the state to hire him to build the bridge. Watson built the swing bridge illustrated on this card in his shipyard, floated it downstream, and in 1902, positioned it.

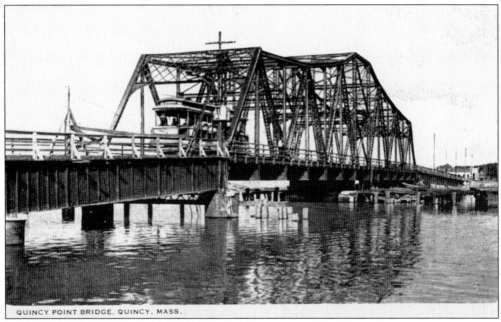

QUINCY POINT BRIDGE. QUINCY. MASS.

A trolley crosses the Fore River on Watson's steel swing bridge. It was not until around 1810 that the Fore River was first bridged, connecting Quincy to Weymouth and significantly shortening the land miles from the Boston and Quincy side to the communities farther south. Previously stagecoaches had to use a river crossing far upstream. The original wooden Fore River bridges needed relatively frequent replacement.

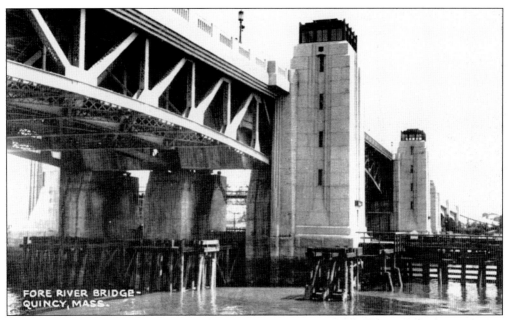

FORE RIVER BRIDGE-
QUINCY, MASS.

A look at the underside of the "new" Fore River Bridge shows nooks and crannies that afforded nesting places to various birds. The volume of birds created a safety and operating hazard. The obligatory removal of this hazard sometimes aroused the ire of the citizenry. The pilings (dolphins) offer the bridge supports some protection from passing vessels. Notice the windows that allow the bridge operators to observe maritime and automotive traffic.

FORE RIVER BRIDGE. QUINCY. MASS.

The "new" Fore River Bridge opened to traffic in 1935. It was a drawbridge that allowed even larger boats to be manufactured in the Fore River Shipyard. Larger petroleum-carrying ships were able to make deliveries to the Cities Service facility in Braintree. Many newly manufactured United States warships passed under the bridge, their initial voyage carefully watched by local boating enthusiasts. The new bridge was dismantled in 2004.

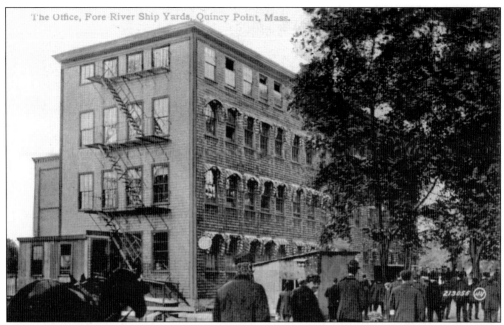

The Office, Fore River Ship Yards, Quincy Point, Mass.

Quincy is rightfully proud of the 102-year history of the Fore River Shipyard. The main access to the yard was located on East Howard Street. The buildings that faced East Howard Street housed the administrative offices and the naval architects' facilities. One of the early buildings of the yard is illustrated in this image.

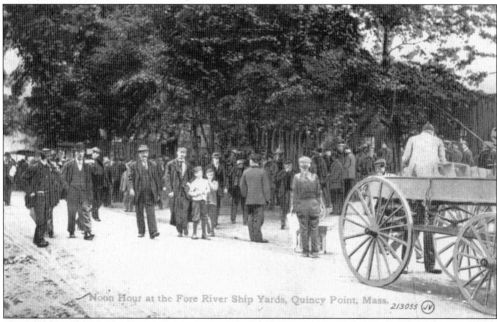

Noon Hour at the Fore River Ship Yards, Quincy Point, Mass.

The majority of workers at the shipyard were men, as illustrated in this noontime scene. Women were employed in clerical positions. It was not until the World War II draft reduced the pool of available men that women started working at the actual construction of ships. In order to fill its need for skilled workers, the shipyard operated apprentice programs from its earliest days until it closed in 1986.

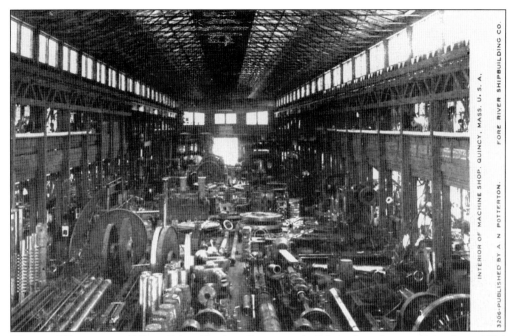

Thomas Watson started Fore River Engine Company, builder of marine engines, about 1884 in Braintree, about two miles upstream from the Fore River Bridge. When the company was moved to its new location, about 1902, one of the first buildings constructed was a machine shop. This pre-1907 postcard provides a view of the interior of that shop. Better quality control was accomplished by controlling the manufacture of component parts.

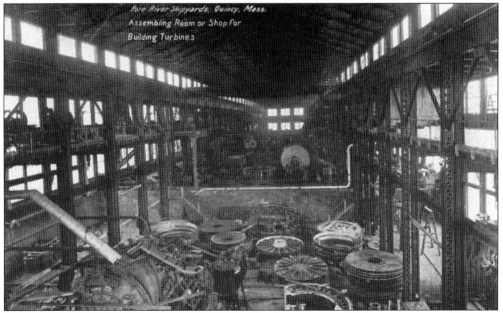

"What is going on inside? What does the inside look like?" The general public asked those questions about industrial buildings as well as historic homes. The postcard industry responded by trying to answer the public's questions. This postcard gives the public a glimpse of the interior of the turbine assembly room at the Fore River Shipyard. (Courtesy Mike Del Greco.)

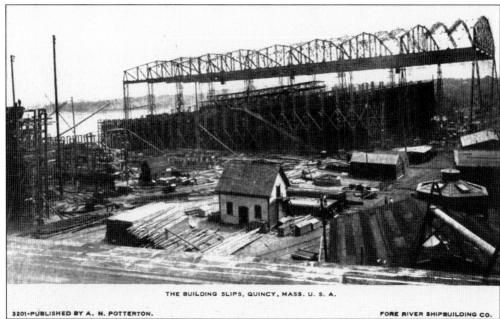

THE BUILDING SLIPS, QUINCY, MASS. U. S. A.

3201-PUBLISHED BY A. N. POTTERTON. FORE RIVER SHIPBUILDING CO.

The two postcards on this page are from the pre-1907 era. The large white area on the front of the cards is for the sender's message; the backs are for address only and are undivided. In the above image, the hull of a ship under construction is clearly visible. The shoreline in the distance is Braintree. The image below is a general view of the main street of the yard. Notice the railroad tracks and the steam engine operating on them. The shipyard had its own short-line railroad servicing it. The short-line railroad still functions, servicing one of the businesses that now occupy the former shipyard.

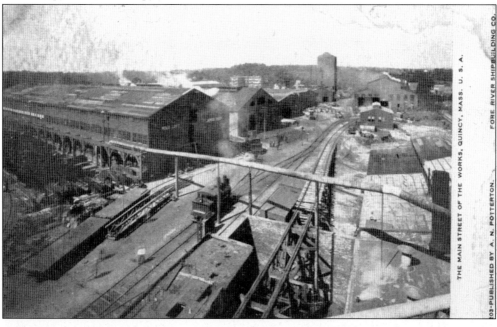

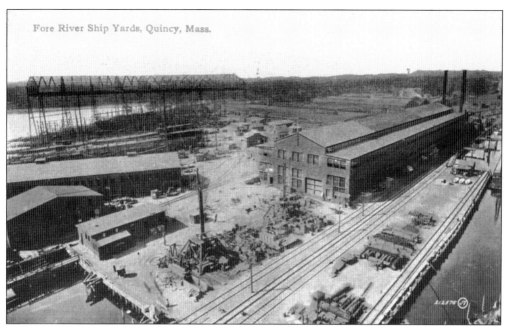

Fore River Ship Yards, Quincy, Mass.

The two real-photo images on this page are from the same era as the preceding page. However, they were printed after 1906, and the white area left for a message is omitted. The back is equally divided into message space and address space. One card is postmarked 1910. Notice the abundance of railroad track in both images. Steam engines were used to move heavy materials about the shipyard. Cranes lifted the materials into place. The boatbuilding slips are conspicuous in the image above. The long building to the right of the image below has two labels, "Mold Loft" and "Joiner Shop." The four images on these two facing pages are taken from the top of one of the yard's cranes.

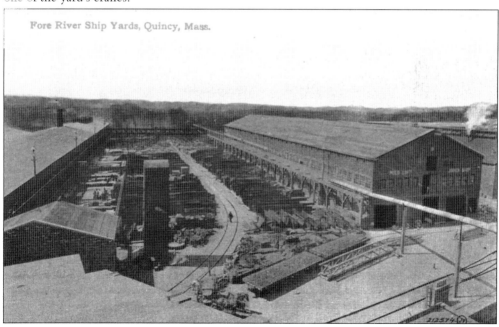

Fore River Ship Yards, Quincy, Mass.

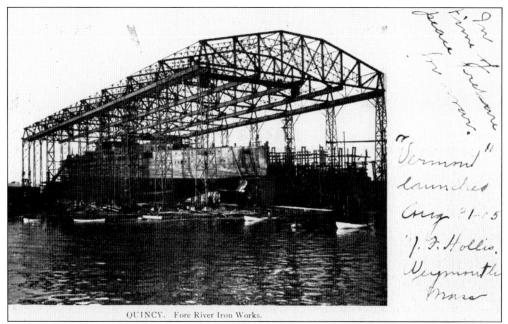

QUINCY. Fore River Iron Works.

This card, postmarked 1905, gives a view of the battleship *Vermont* under construction in the summer of 1905. Notice the number of private boats that have come to view the construction. During its 102-year history, the Fore River Shipyard built merchant ships that plied the world, lightships that warned mariners of dangerous waters, and warships, including submarines, for the United States and other nations.

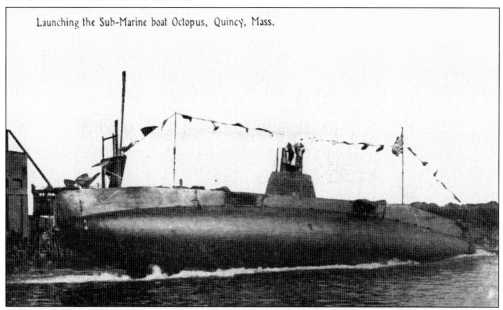

Launching the Sub-Marine boat Octopus, Quincy, Mass.

The postmark on this card is 1908, the same year that the submarine *Octopus* was delivered to the Electric Boat Company of Connecticut. The Fore River Shipyard manufactured many submarines for the Connecticut firm. General Dynamics purchased the Electric Boat Company and, in 1964, General Dynamics purchased the Fore River Shipyard. There was no shortage of shipbuilding contracts in the first half of the 20th century.

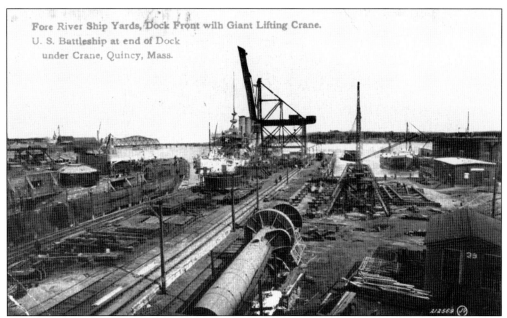

Fore River Ship Yards, Dock Front with Giant Lifting Crane.
U. S. Battleship at end of Dock
 under Crane, Quincy, Mass.

This view of a Fore River dock enables the viewer to visualize how the "giant lifting crane" is moved back and forth on the dock. The crane is moved on parallel tracks as it bridges the materials stored on the dock. After General Dynamics purchased the shipyard in 1964, it installed "Goliath," an even larger giant crane that was able to lift and position entire preassembled sections of ships.

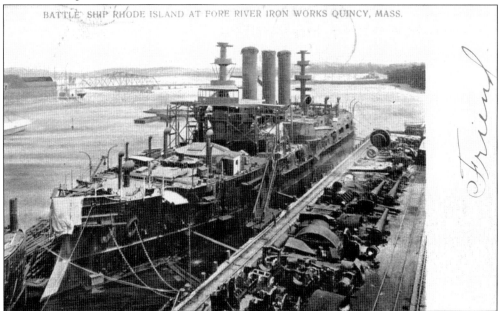

BATTLE SHIP RHODE ISLAND AT FORE RIVER IRON WORKS QUINCY, MASS.

The battleship *Rhode Island* was launched from the Fore River Shipyard in 1906, the same year as the postmark on this card. In the left background, the 1902 bridge over the Fore River is visible. Battleships were named after states of the United States; cruisers, next in fire power to battleships, after U.S. cities; aircraft carriers after Revolutionary War sites, insects, and U.S. presidents; and destroyers after notable people.

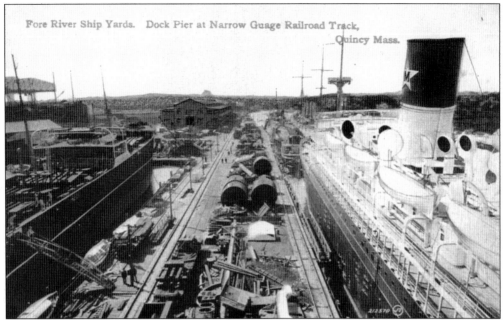

When transoceanic travel was primarily by passenger ships, the Fore River Shipyard made its fair share of cruise ships. The ship illustrated here was one of two manufactured in 1931 and 1932 for Oceanic Steamship Company, a subsidiary of Matson Lines. The angled smokestack indicates that the ship burned oil for fuel. The perpendicular smokestack indicates that the ship burned coal for fuel.

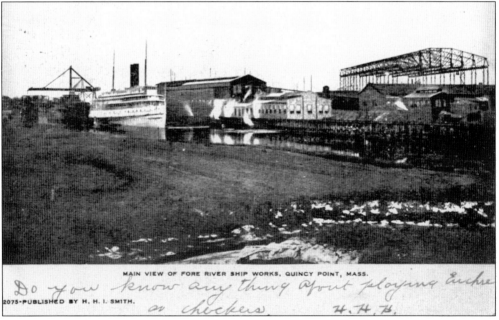

The image on this early postcard gives another general view of the shipyard. Beyond the buildings, the image shows the giant lifting crane and the framework over the shipbuilding basin. This card was used by a boy to send a "Thank you for the birthday gifts" note to his grandparents in 1906.

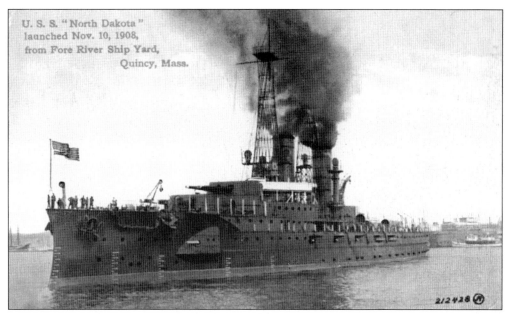

U. S. S. "North Dakota" launched Nov. 10, 1908, from Fore River Ship Yard, Quincy, Mass.

This full photograph postcard expresses the pride of the shipyard workers in their craftsmanship. The battleship is the *North Dakota*, launched on November 10, 1908. It survived World War I and was scrapped in 1931. The straight-up-and-down smokestacks indicate that it was a coal-burning ship.

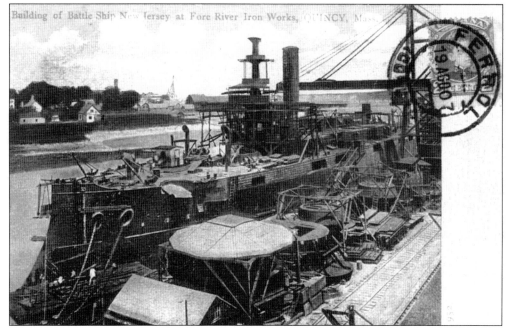

Building of Battle Ship New Jersey at Fore River Iron Works, QUINCY, Mass.

The *New Jersey* was the first battleship launched at the new Quincy shipyard. In 1906, it began its service to the United States Navy. The ship's service ended when it was used as a target ship in 1922. A postcard collector affixed a Spanish postage stamp to the face of this card and had the stamp cancelled in order to document the date. The card was never mailed.

From around 1880 to 1910, across the Fore River from Quincy Point, the recreational area known as Lovell's Grove flourished. Two steamers a day brought tourists and vacationers there from Boston. This postcard shows the vacationers/tourists rowing on the Fore River, sometimes in overcrowded boats. Lovell's Grove is in the background. On the left margin, one can barely make out the wooden bridge that preceded Watson's 1902 steel bridge.

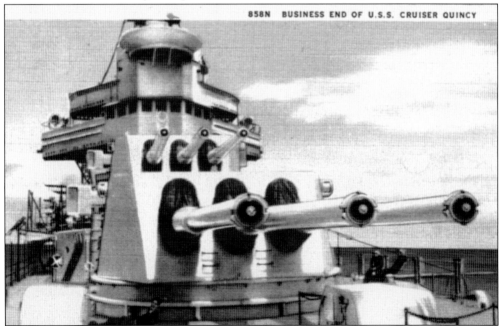

858N BUSINESS END OF U.S.S. CRUISER QUINCY

Among the many ships manufactured by the Fore River Shipyard, one was named in honor of the city of Quincy. The heavy cruiser *Quincy* was manufactured for the United States Navy and launched at the shipyard in 1936. In 1942, the USS *Quincy* was supporting the invasion of the island of Guadalcanal when it became engaged in the Battle of Savo Island and was sunk by Japanese shells and torpedoes.

Five

SCHOOLS

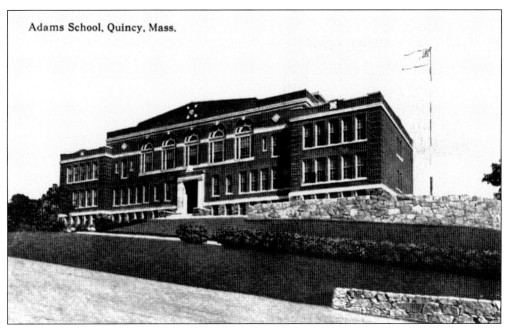

Adams School, Quincy, Mass.

Built in 1913, the Adams School, snuggled between Kendrick Avenue and Abigail Avenue, was part of a school building boom from 1912 to 1920. Some of the other schools that were part of that building boom were the Montclair School, the Squantum School, and the Webster School. The original Adams School (1855–1925) was named to honor John Adams. The magnificent 1913 schoolhouse has been converted to condominiums and is now known as Academy Park.

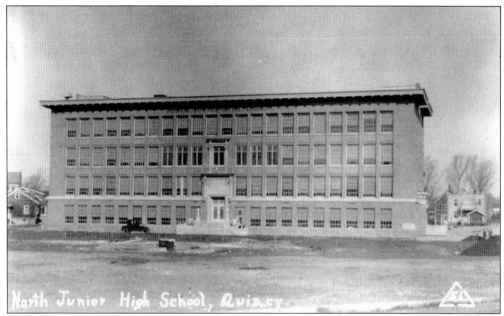

In the 1920s, Quincy incorporated junior high schools into its educational system. The old high school, an addition to Quincy Point's Daniel Webster School, and a new building in the Atlantic section of town were utilized to accomplish this goal. This real-photo postcard shows the 1926 Atlantic Junior High School as it neared completion; with major additions, about 1931, it became the North Quincy High School of today.

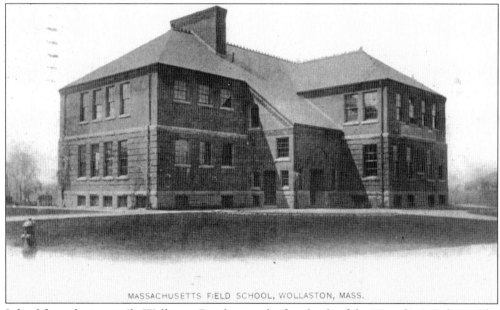

Inland from the two-mile Wollaston Beach were the farmlands of the Masachusit Indians. The farmlands were known to Capt. Richard Wollaston and his crew of explorers as Masachusit Fields. The area has retained the name for almost four centuries. The word Massachusetts evolved from the name of these Native Americans. The Massachusetts Fields School, located on Beach Street, was built in 1896. The school has since been converted to apartments.

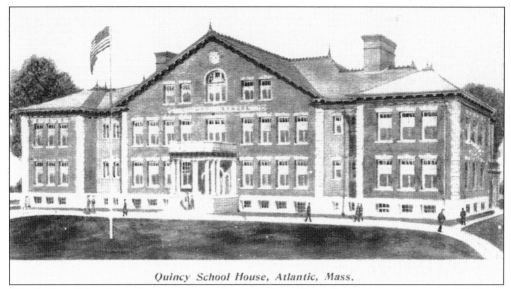

Quincy School House, Atlantic, Mass.

The Quincy School, an elementary school on Newbury Street in the Atlantic section of Quincy, was built in 1906. An interesting feature of the school is the polished Quincy granite columns that adorn its front entrance. It served the children of North Quincy for over three-quarters of a century before declining enrollment forced its closure. In 1982, the school was sold to developers and was converted to condominiums.

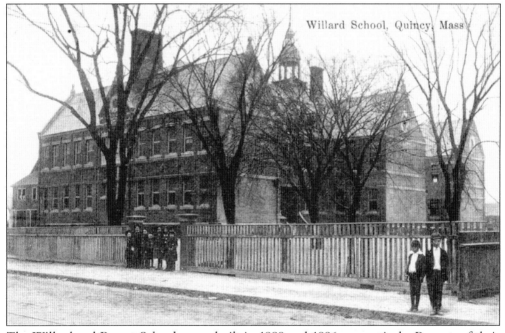

Willard School, Quincy, Mass

The Willard and Bryant Schools were built in 1889 and 1896, respectively. Because of their proximity to the Granite Railway's route (now mostly buried under the Southeast Expressway) the similarly constructed schools were named to honor Solomon Willard, whose inventions made granite quarrying practicable, and Gridley Bryant, the engineer who built the Granite Railway. The school illustrated on this postcard is the Willard School. Both schools are now office condominiums.

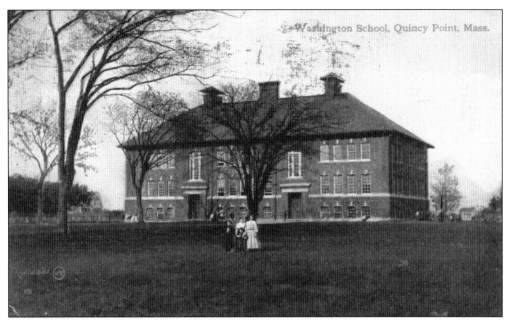

Quincy Point's Washington School was located in a residential neighborhood at the intersection of Curtis Avenue and Washington Court. One of the parcels of land upon which the Washington School was built had been used as the site of a schoolhouse since 1808. The schoolhouse illustrated was built in 1903. It is now the site of the Quincy Housing Authority's Pagnano Towers.

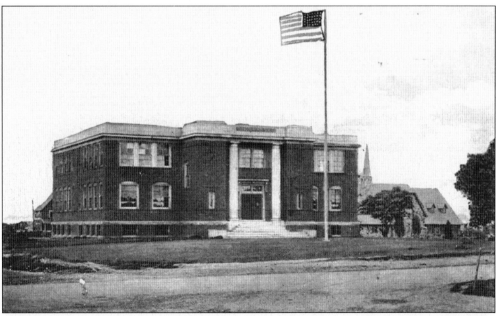

The Atherton Hough School, 1084 Sea Street, was established in 1911. Built originally as a small neighborhood school, it has been expanded significantly and is still active in Quincy's public education. It was named in honor of Atherton Hough, one of the early landholders in Quincy. Hough was mayor of Boston, England. When he migrated to the United States, he continued his political activities. (Courtesy Mike Del Greco.)

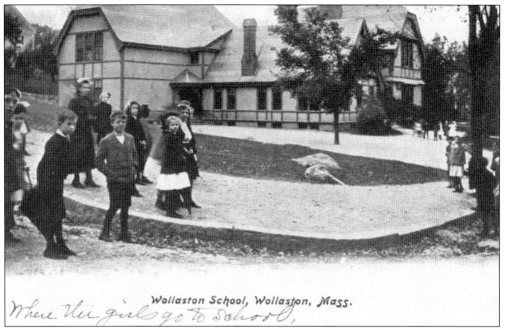

Wollaston School, Wollaston, Mass.

Where the girls go to School,

The original Wollaston School on Beale Street was completed in 1873. It served the community until it was replaced in 1913. The children do not seem to be in a hurry and are therefore probably on their way to school. This undivided-back card clearly shows children's school clothes of the earliest part of the 20th century. The handwritten message reads, "Where the girls go to school."

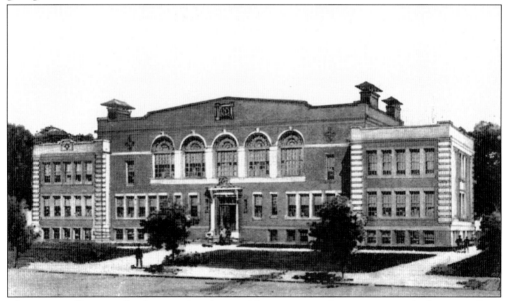

The 1873 Wollaston School was replaced in 1913 by a more modern structure. The large windows and high ceilings were the air-conditioning of the era. The school has been modernized and still serves the community as an elementary school. The Wollaston section of Quincy is named in honor of Capt. Richard Wollaston, who established a settlement in what is now the Wollaston section of Quincy.

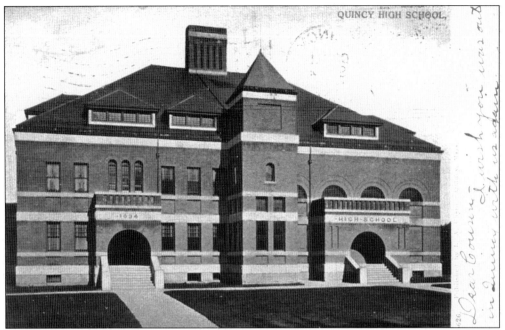

In 1852, Quincy built its first free high school on High School Avenue. It was a wood frame building. In 1894, the second Quincy High School was completed on Hancock Street, at the corner of Butler Road, opposite the Dorothy Quincy House. The home of the original Edmund Quincy was on this site from 1635 to 1894. The card illustrated is of the undivided-back variety and postmarked 1906.

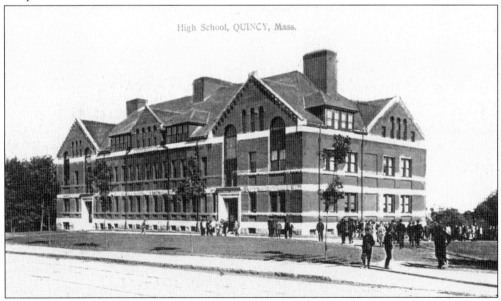

High School, QUINCY, Mass.

In order to keep up with the city's rapid growth of population in the 1890s Quincy High School had to grow. In 1906, when the Hancock Street high school was only 12 years old, the city had major renovations and an enlargement made to the high school. The two images on this page are the same high school, but the extent of the renovations makes the images appear as though they were two different buildings.

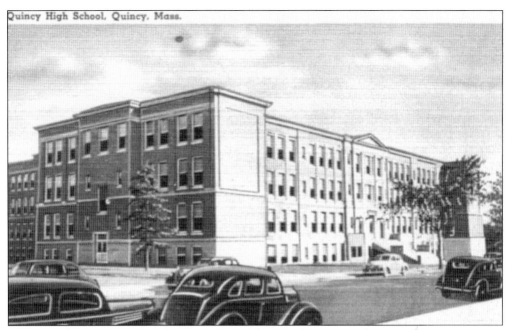

The current Quincy High School was built in a typically urban style in 1924. It is located on Coddington Street and, with additions and renovations, has served Quincy's youth for over 80 years. About 2,000 students attend the school, which is currently being expanded. The card illustrated above is from the early 1940s.

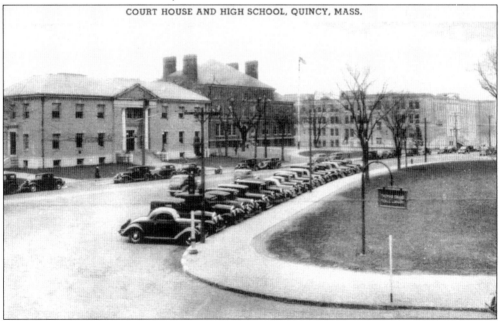

COURT HOUSE AND HIGH SCHOOL, QUINCY, MASS.

This card shows the educational complex on Coddington Street. Looking across the Thomas Crane Public Library lawn, one can see the 1912 East Norfolk County Courthouse (now razed) on the left. The 1908 Coddington Elementary School is in the center. After meeting the needs for which they were constructed, both buildings provided classrooms for Quincy High School and Quincy College in the 1970s. To the right is the 1924 Quincy High School.

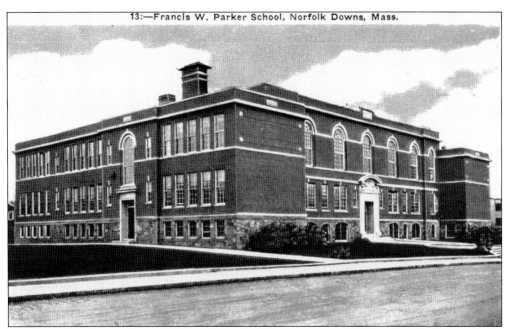

Construction of the Frances W. Parker School on Billings Road was completed in 1917. Francis W. Parker was superintendent of the Quincy Public Schools from 1875 to 1880. His enlightened approach to education was in contrast to the stern approach of the past, and his approach to education became known as the "Quincy System." The system was copied throughout the United States. (Courtesy Mike Del Greco.)

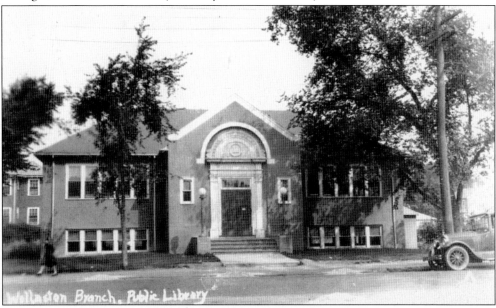

An exceedingly important part of any city's educational program is the city's library. The Thomas Crane Public Library, started in 1871, is considered one of the finest libraries in the state. The Thomas Crane Public Library extends its services to various parts of the city through branch libraries and bookmobile service. The 41 Beale Street branch of the library (built in 1922) is shown on this *c.* 1930 real-photo postcard.

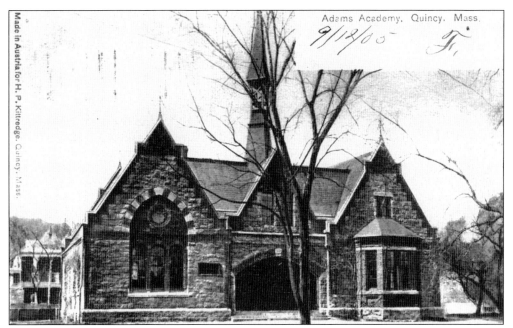

Adams Academy. Quincy. Mass.

In 1822, when a free high school education was not available, former president John Adams did what he could to enhance the educational opportunities of Quincy's youth. He donated the land and the finances to erect an academy over the birthplace of John Hancock. By the time Adams Academy opened in 1872, a free high school education was becoming available. In 1907, Adams Academy ceased to function as a school.

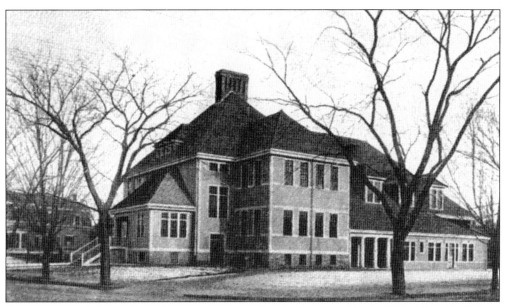

An awareness of the need to educate women was beginning to surface in 1872 when the Adams Academy opened. Dr. Ebenezer Woodward, a cousin of Adams, felt a need to take action. In 1894, he established the Woodward School for Girls, situated at 1102 Hancock Street, at the corner of Greenleaf Street. Originally intended to provide education for Quincy girls only, since 1969, the school admits girls from other communities.

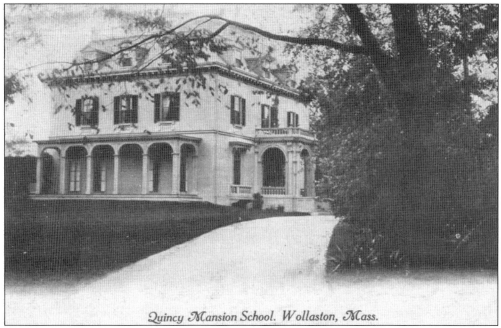

Quincy Mansion School. Wollaston, Mass.

About 1850, the fourth Josiah Quincy (1802–1882) built a second mansion on the Quincy estate in Wollaston. After his death, it was converted to a girls' boarding school, Quincy Mansion School for Girls. The availability of a free public high school education had created difficult times for many private schools. Eastern Nazarene College purchased the property in 1919 and relocated its campus to the site. (Courtesy Mike Del Greco.)

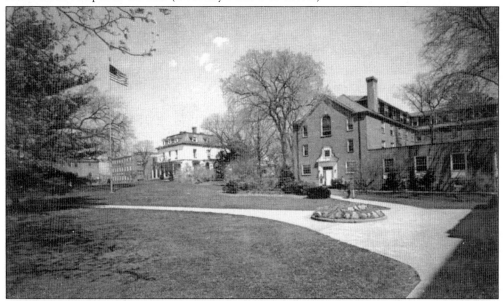

This glossy postcard from the 1960s gives a general view of a portion of the 15-acre Eastern Nazarene College campus. The Quincy Mansion School for Girls building remains standing in this image. The building was razed in the late 1960s, and Gardner Hall was built on the East Elm Avenue site. The college offers a variety of programs of study, including education, business, science, communications, and criminal justice.

72

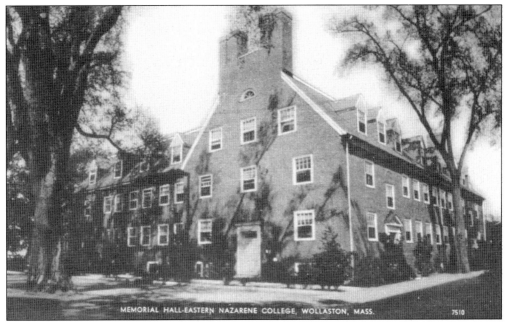

MEMORIAL HALL-EASTERN NAZARENE COLLEGE, WOLLASTON, MASS. 7510

This full black-and-white photograph postcard illustrates one of the dormitories of Eastern Nazarene College. The dormitory, located on Wendell Avenue, provides facilities for male students. The name Wendell is among the Quincy family's descendants. The fourth Edmund Quincy was married to Elizabeth Wendell. A branch of the third Edmund Quincy family leads to Oliver Wendell Holmes, a former chief justice of the Supreme Court.

Map out your future

This modern 4-by-6-inch postcard informed potential students of the benefits of attending Quincy College. In the center of the treasure map is an illustration of one of the buildings of the college. The hunters are focusing their attention on it. The building is the former Coddington School, which has helped meet the college's needs for half a century. (Courtesy Quincy College.)

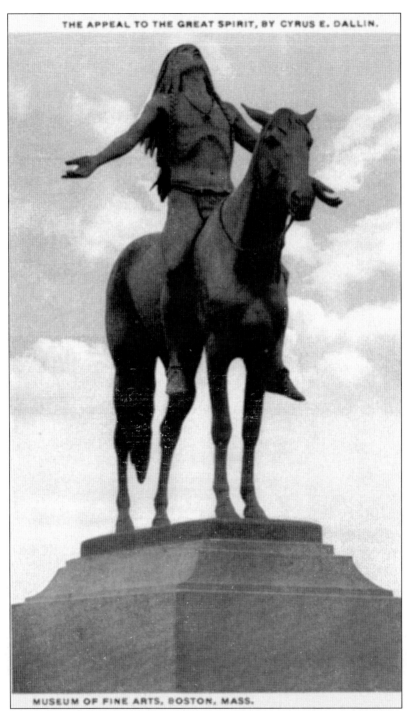

THE APPEAL TO THE GREAT SPIRIT, BY CYRUS E. DALLIN.

MUSEUM OF FINE ARTS, BOSTON, MASS.

The sculptor Cyrus Edwin Dallin was commissioned by Boston's Museum of Fine Arts to create the statue *Appeal to the Great Spirit*. The statue, cast in 1909, has graced the main entry to the museum since its creation. A working model of the statue has become the property of Quincy High School and the emblem of its student body. The working model is displayed in the lobby of the high school. The emblem is lovingly referred to as the "Pony."

74

Six

CHURCHES

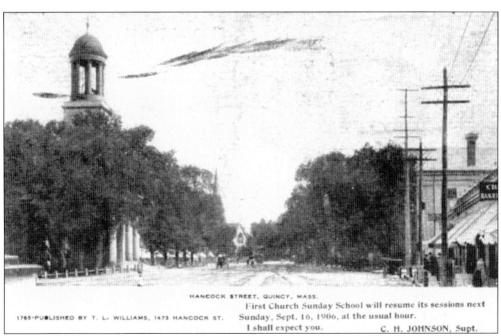

HANCOCK STREET, QUINCY, MASS.

First Church Sunday School will resume its sessions next
1765-PUBLISHED BY T. L. WILLIAMS, 1473 HANCOCK ST. Sunday, Sept. 16, 1906, at the usual hour.

I shall expect you. C. H. JOHNSON, Supt.

Postcards were a quick and efficient way to communicate in 1906. This card was mailed to a young church member only two days before Sunday school was to convene. On this card, the United Unitarian Church is referred to as First Church. Over the years, the church acquired a variety of names. Among the names are Church of the Presidents and the Stone Temple.

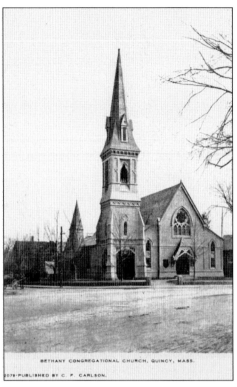

Members of the congregation of this church first gathered in 1832 as the Evangelical Congregational Society. They erected this sanctuary in 1870. It was their second building. In 1896, they changed their name to Bethany Congregational Church. A member of the congregation, Theophilus King, was prominent in Quincy banking. His bank purchased the church property, helped the congregation relocate, and then built the 10-story bank building that now occupies this site.

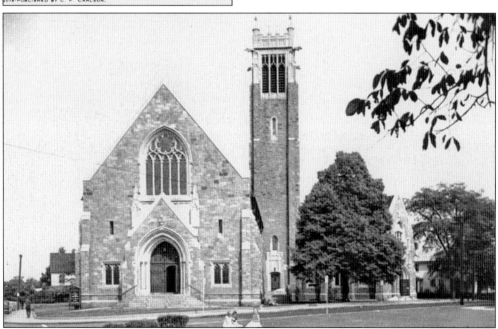

The current sanctuary of Bethany Congregational Church was completed in 1928 and continues to serve its congregation. As a decorative touch, the architect added gargoyles to the steeple. The church is on Coddington Street, the centerpiece of a sphere of architectural delight. The church stands beside the Thomas Crane Public Library, across the street from the Coddington School, within sight of the Stone Temple and Quincy High School.

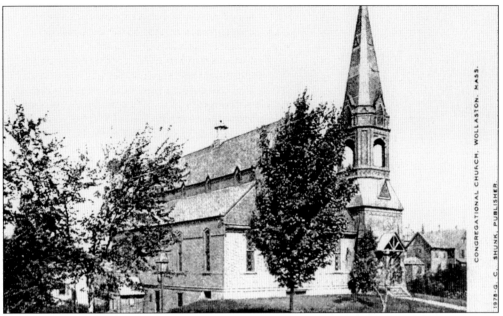

Wollaston Congregational Church, located at 48 Winthrop Avenue, was founded in 1876. The wooden building that was the original church served its congregation until the mid-1920s when it was demolished to make room for the construction of the new church sanctuary. This early-20th-century postcard provides an area on its front for messages and is of the undivided-back variety.

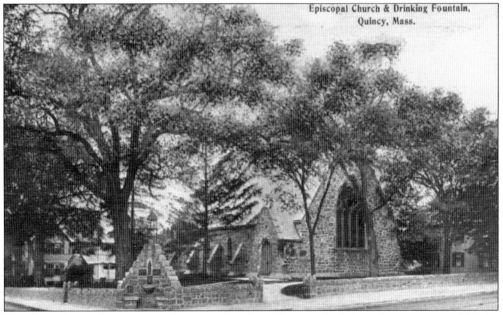

The fountain on the corner no longer exists, but this stone building, the sanctuary of Christ Episcopal Church, still serves its membership and the community. The stone church on this postcard was completed in 1874 and is the congregation's third church on this site and the fourth in its history. The original church was on School Street. This is the oldest Episcopal congregation in Massachusetts and can trace its history to 1689.

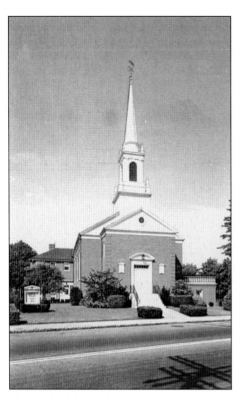

The original building of Quincy Point Congregational Church was dedicated in 1838 as a Methodist church. The building was located at the corner of South and Washington Streets. In 1884, the membership changed its creed to Congregational. In 1948, the original building was moved to its present location on Washington Street, near the Southern Artery, and was incorporated into the larger building, which is seen in this postcard.

This colorful rotograph postcard gives a close-up view of the St. Francis by the Sea Church. In 1915, the parish changed its name to Most Blessed Sacrament Parish. It has since been merged into Holy Trinity Parish. Rotograph Publishing Company cards are in high demand among postcard collectors. The images portrayed on them may be found in black and white or hand colored.

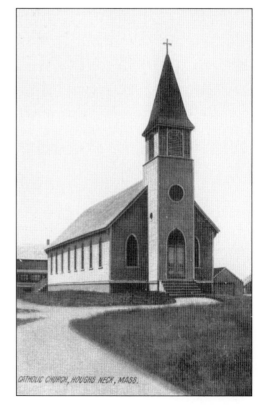

CATHOLIC CHURCH, HOUGHS NECK, MASS.

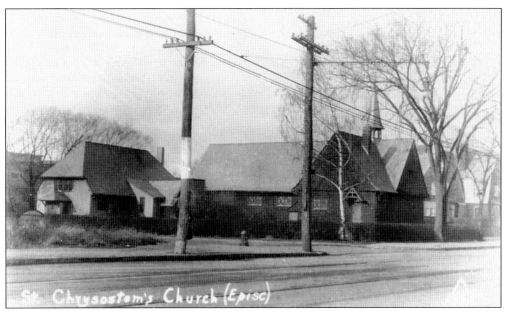

St. Chrysostom's Church (Episc)

Because of overcrowded conditions at Christ Episcopal Church, members from the northern section of the city formed a new church. The new church was named for St. Chrysostom. By 1894, the members of the new church were sufficiently well organized to start construction of their own place of worship at 523 Hancock Street. In the early 1950s, the membership built a stone church on the same site as the building illustrated.

St. John the Baptist Catholic Church was built to service the needs of the Catholic quarry workers moving into Quincy. The new church was dedicated in 1853 and is now the oldest Catholic church structure in Quincy. The original Christ Episcopal Church was near the site of St. John the Baptist Catholic Church, and the cemetery adjacent to St. John the Baptist Catholic Church is that of the original Episcopal church.

ST. JOHN'S CATHOLIC CHURCH, QUINCY, MASS. - 7439.

79

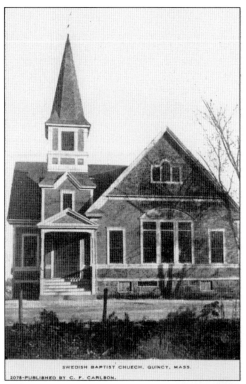

SWEDISH BAPTIST CHUECH, QUINCY, MASS.
2078-PUBLISHED BY C. F. CARLSON.

This pre-1907 postcard shows the Swedish Baptist Church as it existed before its merger with Calvary Baptist Church in 1922. The churches combined as Central Baptist Church. Services were conducted in Swedish before the merger. The message on this card, sent from Quincy to Brockton, is written in Swedish. Church services in foreign languages are still conducted in Quincy to accommodate the needs of today's immigrants.

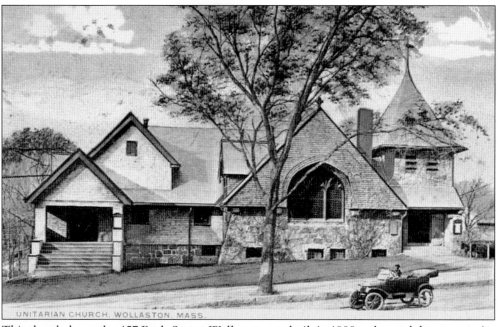

UNITARIAN CHURCH, WOLLASTON, MASS.

This church, located at 157 Beale Street, Wollaston, was built in 1888 and served the community as a Unitarian church and still graces the community with its architecture. In 1960, the Unitarian congregation merged with United First Parish Church of Quincy (also known as the Stone Temple). The church building continued to serve the community as the St. Catherine's Greek Orthodox Church of the South Shore until its conversion to apartments about 2005.

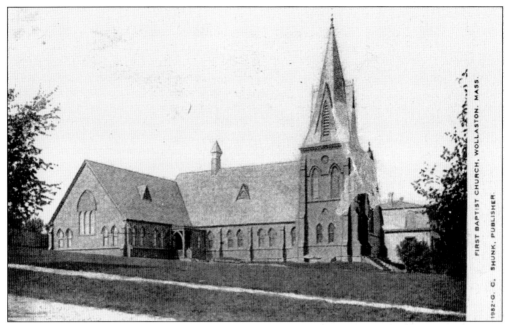

The First Baptist Church of Wollaston Heights was organized in 1871. The congregation met in the Wollaston Hotel while a chapel was built for worship services. In January 1873, the new chapel was dedicated. In 1902, the church changed its name to the First Baptist Church of Wollaston. (Courtesy Mike Del Greco.)

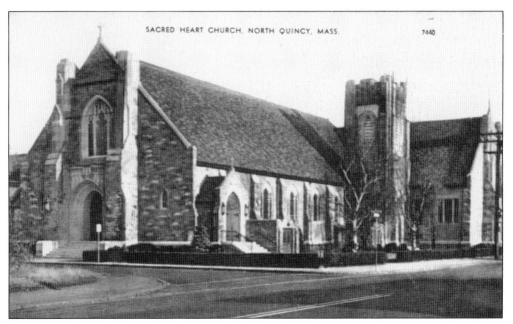

By 1920, the Catholic population of North Quincy had grown to such an extent that a new larger place of worship was needed. Planning and construction on Sacred Heart Church in North Quincy was begun in the early 1920s, and, starting in 1924, services were conducted in the basement of the church while the remainder of the church was completed. The church is located on Hancock Street.

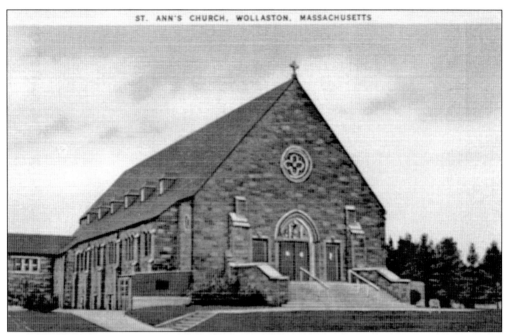

St. Ann's Parish was formed in 1922. Masses were held in the Masonic building on Beale Street until a church structure was complete. In November 1925, the first mass was said in the new St. Ann's church.

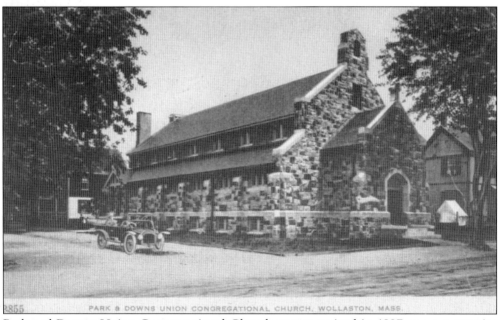

PARK & DOWNS UNION CONGREGATIONAL CHURCH, WOLLASTON, MASS.

Park and Downs Union Congregational Church was organized in 1897 as a community church served by visiting clergymen. Its purpose was to provide a local place of worship for the communities of Wollaston and Norfolk Downs. In 1900, the members affiliated their church with the Congregational denomination. The church building is located on Rawson Road, across the street from the former Massachusetts Fields School.

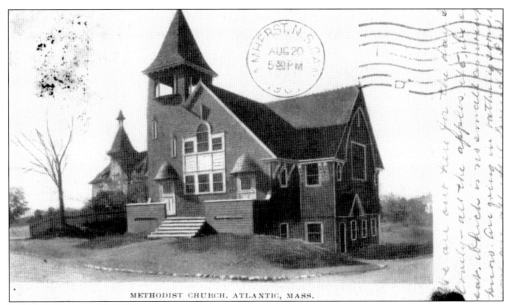

This Methodist church stood on East Squantum Street at the intersection with Hunt Street. The schoolhouse in the background is the wooden 1873 Quincy School. When this undivided-back card was sent, it was postmarked August 19, 1904, Atlantic Station, Quincy, on the address side. When the card was received in Canada the next day, it was postmarked August 20, 1904, Amherst, Nova Scotia, on the picture side.

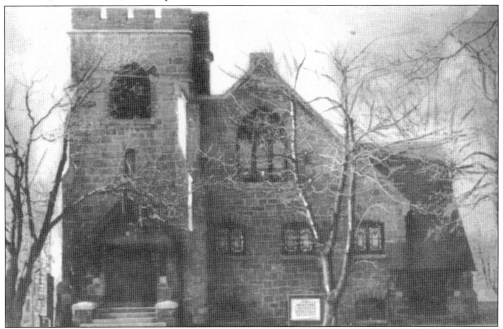

Newbury Street intersects with both Hunt and East Squantum Streets at the Methodist church pictured at the top of this page. Memorial Congregational Church is a short distance away at 65 Newbury Street. The original congregation was gathered in 1874. Today the church serves the Atlantic community as the Evangelical Church of Atlantic. This white-bordered card is postmarked 1948.

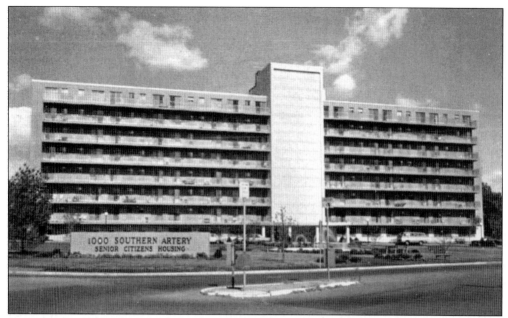

As part of its service to the community, the Quincy Point Congregational Church sponsored the construction of the building illustrated on this postcard. It contains 216 apartments designed to provide comfortable housing to senior citizens. In addition to apartments, it provides social, recreational, educational, and fellowship activities. This, the original building, was erected in 1965. Located at 1000 Southern Artery, the complex is commonly referred to by its street address.

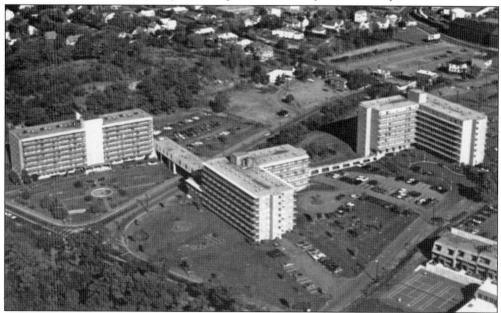

The overwhelming acceptance of the first senior housing building encouraged Quincy Point Congregational Church to expand the project. This more recent aerial view of the 1000 Southern Artery senior citizen complex shows the three buildings connected by enclosed walkways. Each building contains about 200 apartments. In addition to apartments it provides social, recreational, educational, and fellowship activities. South Street and Des Moines Road divide the complex.

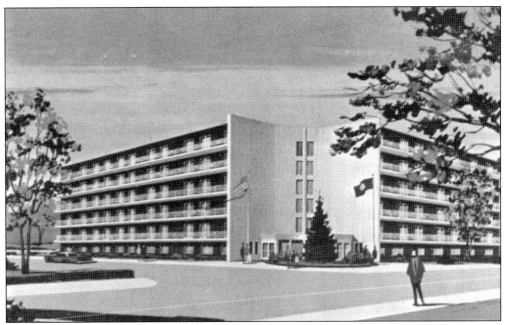

Wollaston Lutheran Church also sponsored a Housing for the Elderly project. Located at 540 Hancock Street, this building is currently providing assisted living facilities to the elders of the community. The building was dedicated in 1973. Numerous Housing for the Elderly projects are scattered throughout the city of Quincy.

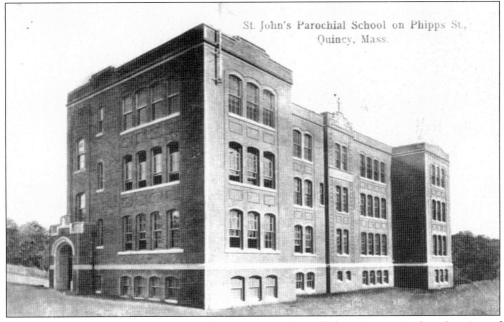

Another area in which churches contribute to the quality of life in Quincy is the education of the young. This school on Phipps Street was established in 1909 by St. John the Baptist Catholic Church. In the mid-1970s, the full-time school closed. The building is now used for the church's religious education program. Other churches in Quincy are currently conducting full-time elementary schools. (Courtesy Mike Del Greco.)

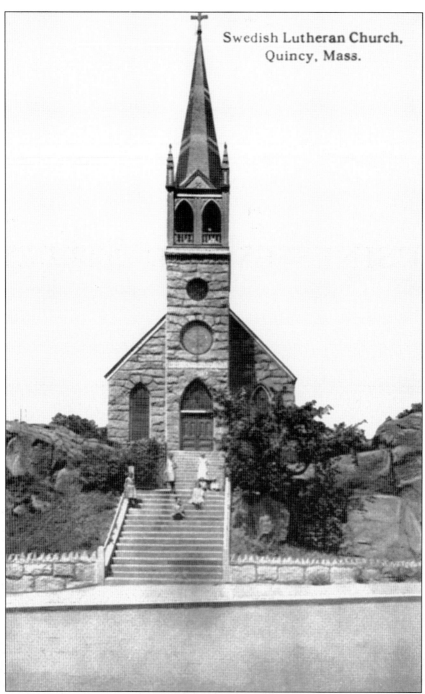

Swedish Lutheran Church,
Quincy, Mass.

The congregation of this church organized in 1889 as the Swedish Evangelical Lutheran Salem Church. In 1891, it decided to purchase the land seen here. The lot, dominated by a granite ledge, is situated on appropriately named Granite Street. The congregation quarried its own stone and had the church built on top of the granite ledge. Two years later, the edifice was complete. Today the magnificent structure watches the city's motor vehicle traffic flow on busy Granite Street, while the church continues to serve its congregation.

Seven

Businesses and Streets

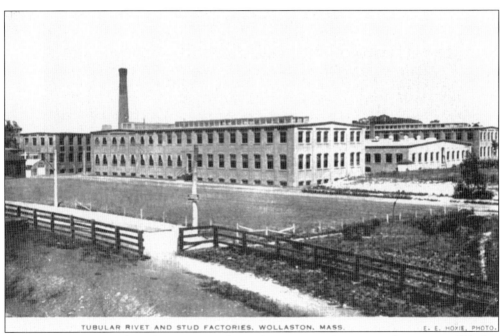

TUBULAR RIVET AND STUD FACTORIES, WOLLASTON, MASS. E. E. HOXIE, PHOTO.

The Tubular Rivet and Stud Factory was located on Weston Avenue, at the corner of Linden Street in the Wollaston section of Quincy in close proximity to the railroad tracks. It had provided steady employment for hundreds and stimulated the local economy. Like so many other manufacturing facilities in the northeastern United States, Tubular Rivet and Stud Factory has closed its doors. (Courtesy Mike Del Greco.)

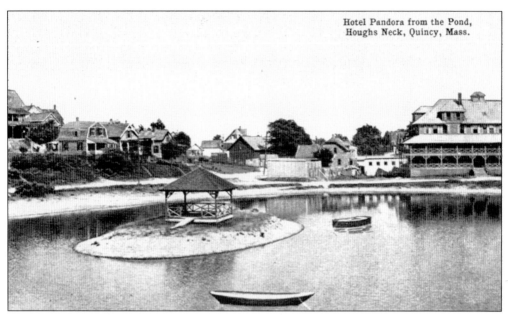

Hotel Pandora from the Pond, Houghs Neck, Quincy, Mass.

When Hough's Neck was a refuge for vacationing Bostonians, the Pandora Hotel prospered. It was situated on the shore of a man-made tidal lake at the base of Great Hill. Bands played in the gazebo in the middle of the lake. The hotel functioned under several names, including Fensmere and Crystal. After the hotel closed, the lake was allowed to drain, and the site is now a park meeting the needs of the current residents.

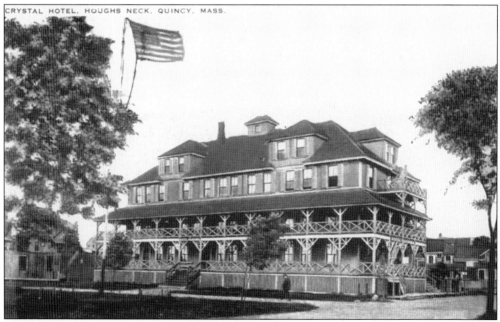

CRYSTAL HOTEL, HOUGHS NECK, QUINCY, MASS.

This card offers a closer look at the same hotel. The salt air, the sea breezes, and businesses of a recreational nature made Hough's Neck popular as a vacation destination. The same qualities made the "Neck" a desirable place to live year round. The needs and interests of year-round residents have changed the Neck into a residential community rather than a tourist destination.

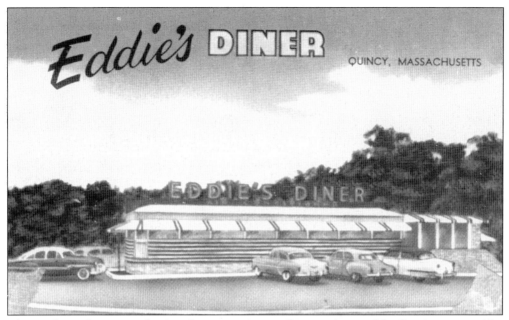

This 24-hour diner was a landmark to motorists until it was damaged by fire. It was saved by the American Diner Museum and has since been moved to Westport, Massachusetts where, after renovations are complete, it will resume operations. The diner and adjoining Eddie's Motel were located at the junction of Quincy Avenue and Southern Artery. The site is now occupied by South Shore Savings Bank.

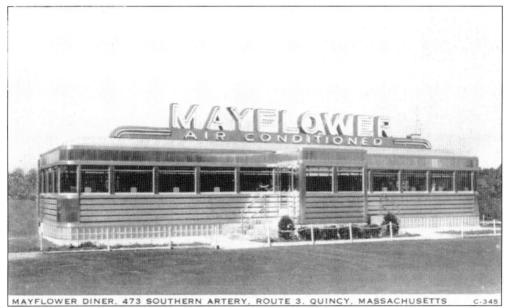

The Mayflower Diner on the Southern Artery, like most diners, was modeled after the railroad train's dining car of the late 19th century. Diners were the fast-food restaurants of the early 20th century. Diners started to succumb to the competition of franchised hamburger chains in the 1950s. As they regain some of their lost popularity, they capitalize on nostalgia and utilize a decor based on the 1950s.

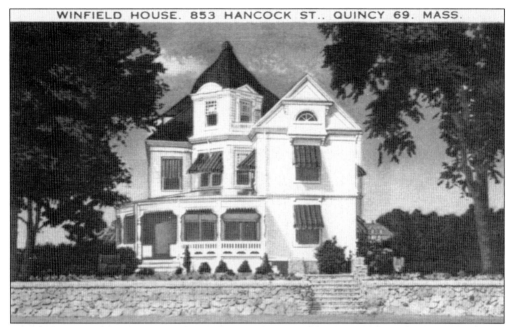

WINFIELD HOUSE. 853 HANCOCK ST., QUINCY 69. MASS.

The Winfield House was a popular restaurant located at 853 Hancock Street, across from Quincy Stadium. The Winfield House promoted itself as the "Big White House by the side of the road" and served "delicious food, expertly prepared." The house successfully used postcards to help promote its restaurant. The house was added to the National Register of Historic Places in 1989. It has since been taken down.

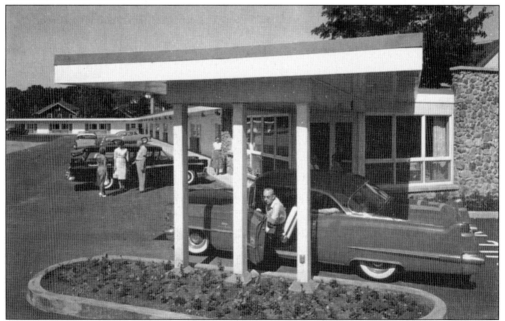

President City Motel is located near the junction of Southern Artery and Hancock Street, adjacent to the site of the Winfield House. A flaming red Cadillac stops at the portal of the newly opened motel. The motel was built in 1960 and contained 36 rooms. In 1996, the motel was renovated. The motel has competed successfully with the large chain hotels and motels.

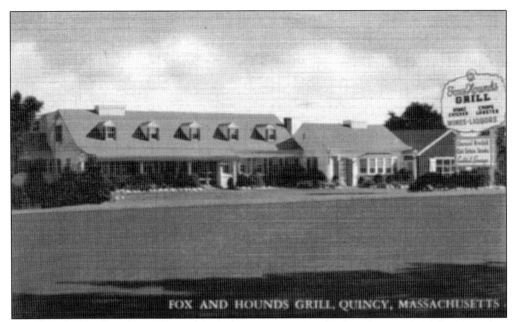

A Fox and Hounds restaurant is located at the southern terminus of Wollaston Boulevard where it meets with Sea Street. Advertising postcards were a highly effective means of getting new customers in the 1930s and 1940s, and eating and lodging establishments often distributed postcards to their customers free of charge. This linen card, postmarked 1946, was distributed free of charge to customers of the restaurant.

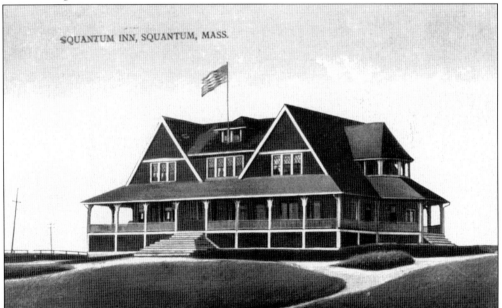

In the 1800s and early 1900s, Squantum was a popular tourist destination for Boston residents. A series of restaurants operated under the name Squantum Inn and/or Squantum House. The last of these survived into the late 1930s. In the early 1900s, inventor Joseph Lee managed one of the Squantum Inns. Lee invented a machine for converting stale bread to crumbs and another machine for automatically making bread.

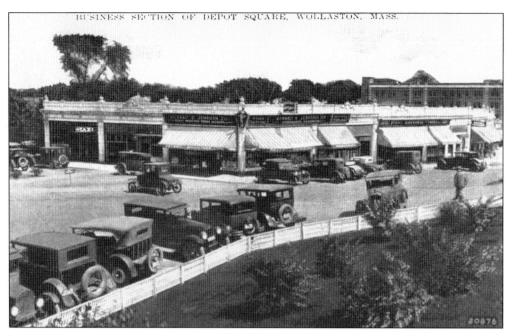

In 1925, World War I veteran Howard Dearing Johnson bought a candy/newspaper/patent medicine/soda/candy store next to the Wollaston Depot in Quincy. This *c.* 1930 postcard shows the storefront's corner location and its proximity to the railroad station. The left two awnings and the overhead signs illustrated on this postcard carry his advertisements. Johnson was not able to develop capital resources while operating this business.

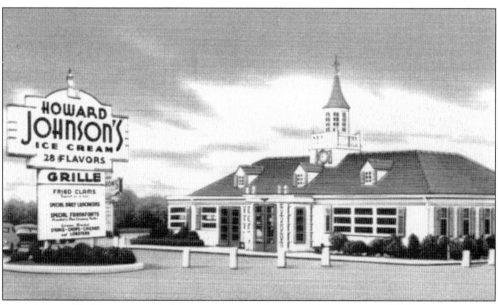

One of the steps Johnson took to improve sales was to create his own recipe for ice cream. In 1935, he convinced a friend to sell the special recipe ice cream under a franchise. This first franchise, in the town of Orleans on nearby Cape Cod, was the start of the Howard Johnson chain of roadside restaurants. The famous orange roof and "Landmark for Hungry Americans" came later.

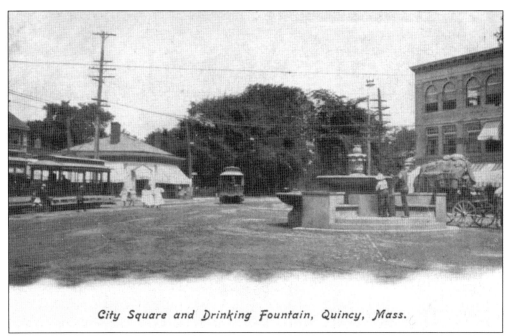

City Square and Drinking Fountain, Quincy, Mass.

The water fountain in the center of the square is reminiscent of an earlier time in history when the watering well was the center of civic activity. Trolleys heading in two directions illustrate the center's history as a junction for public transportation. A horse with a heavily laden wagon waits while the men engage in the great American tradition of socializing at the water bubbler.

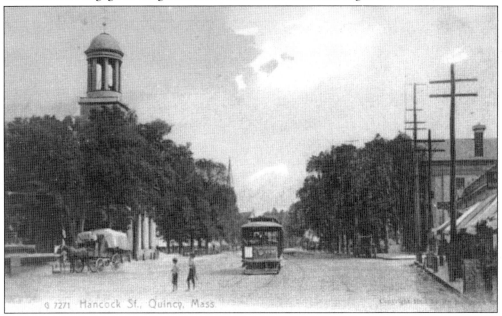

Another view of the same water fountain shows a portion of Hancock Street. The card shows water flowing from one level to another and to a third level. The horses are drinking. The old Bethany Church is visible among the trees. City hall, shoppers, and businesses line the card's right border where the McIntyre Mall now provides open space. This fountain now stands at the Sea Street entry to Mount Wollaston Cemetery.

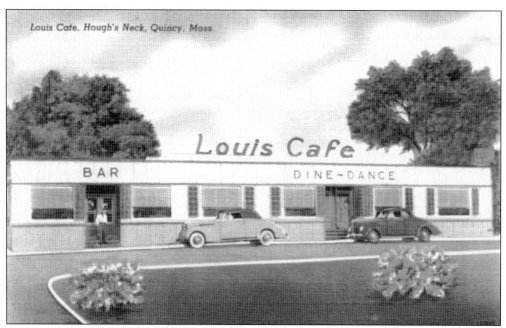

This colorful early 1940s advertising postcard was distributed by Louis Café on Sea Street in the Hough's Neck section of the city. The card tells the potential customer the cafe's address, what its outside looks like, that it serves alcoholic drinks, that seafood is on the menu, and that dancing is available. That's a lot of information on a 3.5-by-5.5-inch postcard.

Like so many restaurants of the era, the Hollow provided free advertising postcards to its patrons. This card shows two interior views of the popular restaurant. The Hollow was located on Adams Street, near the East Milton line. The restaurant was established about 1940. It served luncheons and dinners to the public and accommodated private functions. Adequate parking made it a convenient restaurant to patronize.

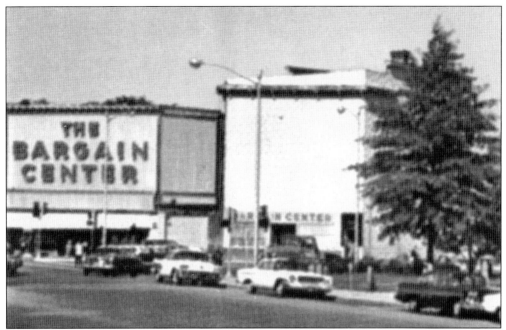

This detail from a 1960s postcard of the Stone Temple gives a clear view of the gone but not forgotten Bargain Center that dominated one end of Quincy Center. For years, thrifty shoppers converged on the "Bargy" looking for—what else—bargains. It had its own rooftop parking facility and was convenient to public transportation. Construction of Presidential Place resulted in the razing of the Bargy in 1986.

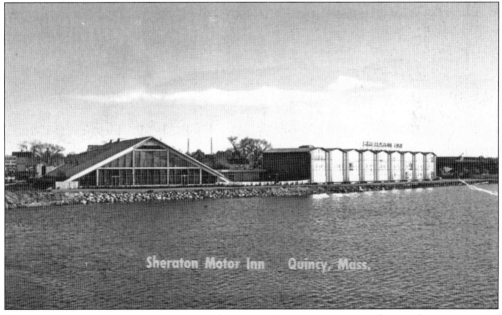

The Sheraton Motor Inn is located on the scenic Neponset River at the northern extremity of Quincy. Its location on the city line between Boston and Quincy makes the motor inn a convenient base for both businessmen and tourists who want to go to either of the two historic cities. It is currently in operation as Best Western Adams Inn.

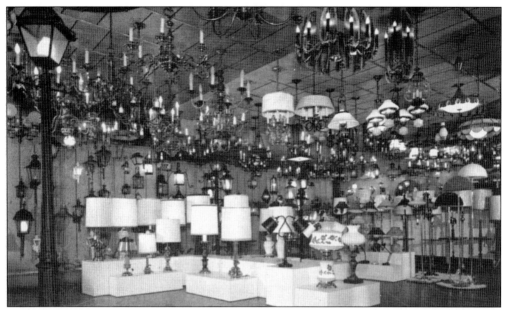

World War I veteran Nicholas Papani, who had emigrated from Italy to the United States in 1912, saw a need for an electric supply company on the South Shore. He named his fledgling company Granite City Electric in honor of his beloved Quincy. Today that supply store has grown to serve three New England states. This promotional postcard shows an assortment of lighting fixtures available at one of its outlets.

In 1947, the Montilio family opened a bakery in Quincy. The business continues today in Boston and has a reputation as baker to dignitaries and presidents. Every longtime resident of Quincy remembers the bakery on Chestnut Street. How many of these longtime residents remember the gift shop? The Montilio's Fruit Orchard and Gift Shop are pictured on the advertising postcard shown above.

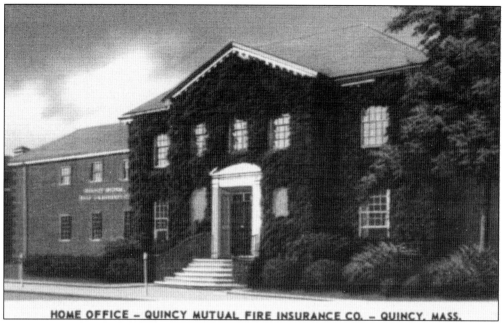

HOME OFFICE - QUINCY MUTUAL FIRE INSURANCE CO. - QUINCY, MASS.

The Quincy Mutual Fire Insurance Company was founded in 1851. It provides a large variety of insurance protection to the general public. The insurance company used postcards, such as the one illustrated above, to advertise its services. This particular postcard, issued in the 1950s, had a customer response postcard attached to it. Postcards are still heavily used to carry advertising messages, but their size is often significantly larger.

'81 Marquis

This advertising postcard was sent to a potential buyer by a salesman from Fore River Motors. Fore River Motors claimed that it was "South Shore's oldest and largest Lincoln and Mercury Dealer." The dealership was located at the junction of Southern Artery and Quincy Avenue directly across the street from Eddie's Diner. The site is now occupied by a Walgreen's drugstore.

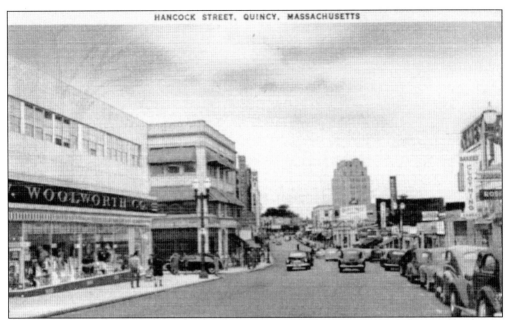

In the 1950s and 1960s, Woolworth's was a key store in Quincy's retail section of Hancock Street. Despite becoming one of the nation's largest retailers, stiff competition and declining sales forced the department store chain to reorganize, and it is now known as Foot Locker. Five-and-dime stores advertised their names with gold letters on a red background and became nicknamed "red and gold gift shops."

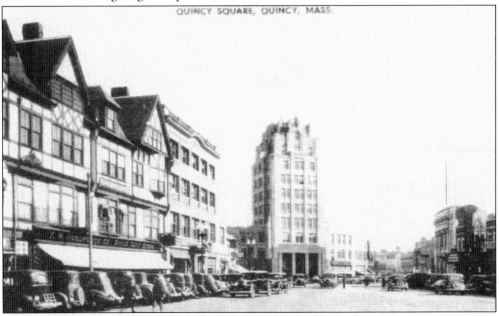

Among the interesting architectural sights in Quincy is the Adams Building. The Tudor architecture of this building is eye-catching. The building is located at the corner of Temple Street and Hancock Street, across from the Stone Temple. The Adams Building has been a landmark since it was built over a century ago in 1890. The sign over the retail shops says, "F. W. Woolworth 5 and 10 cent store."

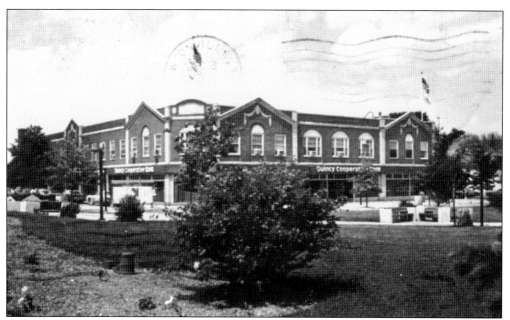

This block in the heart of Quincy Square houses a variety of commercial enterprises. The Quincy Cooperative Bank building and sign are the prominent features on this glossy card. South Coastal Bank now occupies the site. The card is postmarked 1978. The 15¢ postage stamp on the card features Oliver Wendell Holmes, who is a descendant of the Quincy family.

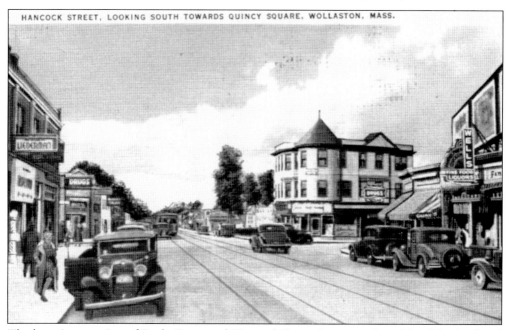

The busy intersection of Beale Street and Hancock Street is captured on this white-bordered postcard. A barbershop, a real estate office, a branch of Quincy Trust Company, and two drugstores help make this Wollaston intersection a busy place. The card is postmarked 1940. The pedestrians all seem to be wearing topcoats and the sender of this card laments about the "just too bad in New England" weather.

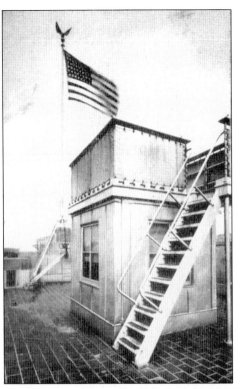

Because of its height and its location, the 10-story-tall bank building overlooks Quincy Center and the surrounding countryside. On this postcard, a 48-star flag is waving from the rooftop of the building. The building was erected in 1929 by the Granite Trust Company while Theophilus King was president. Today it is known as the Bank of America Building. The wooden Bethany Congregational Church had occupied this site.

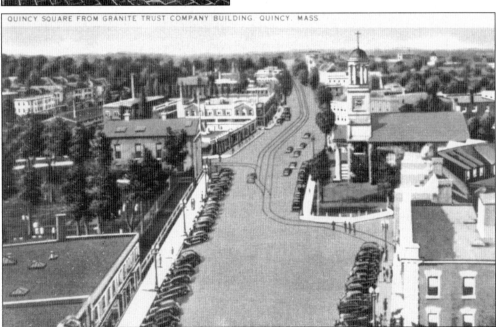

QUINCY SQUARE FROM GRANITE TRUST COMPANY BUILDING, QUINCY, MASS

This 1930s image looks north up Hancock Street toward Boston. It was taken from the rooftop of the Granite Trust Company. The postcard is a linen. It is made of inexpensive paper stock that gives the feel and appearance of linen material. Linens were unpopular with postcard collectors until the recent surge of interest made postcard collecting one of the more popular collecting hobbies.

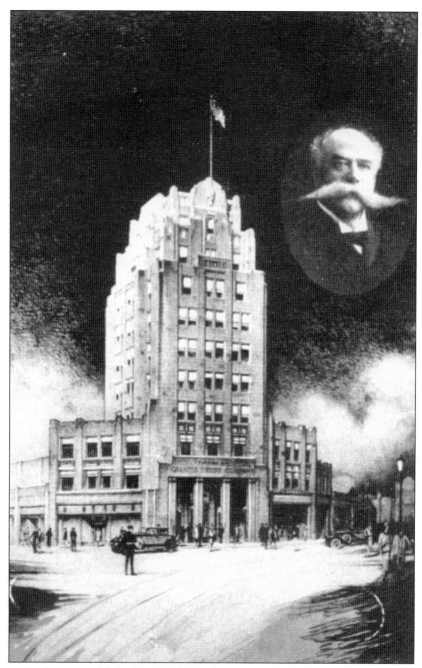

The Stone Bank was established in 1836. By the 1920s, the bank was known as the Granite Trust Company. Theophilus King (inset), a member of Bethany Congregational Church and longtime president of Granite Trust, negotiated a complex exchange whereby the membership of Bethany Congregational Church received land and funds to build its new church building, and the Granite Trust Company received the prime land owned by the church. The bank and 10-story-tall bank building are now a part of Bank of America. Notice when looking at Quincy postcards how frequently Bethany Congregational Church and the Granite Trust Building appear in the background.

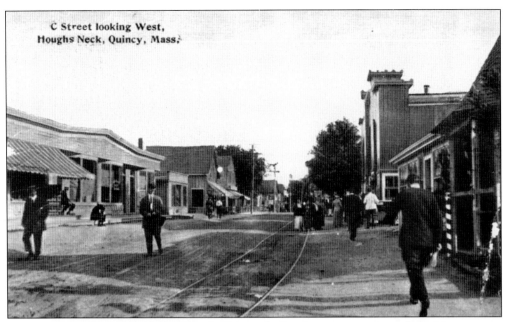

Sea Street runs from the Quincy Police Station on the Southern Artery, through the Merrymount and Adams Shore sections of the city, to Great Hill in Hough's Neck. It was, and still is, the center of commercial activity for Hough's Neck. Hundreds of businesses, past and present, many oriented toward the needs of the tourist, were located on Sea Street. The sender comments on the poor quality of her pen.

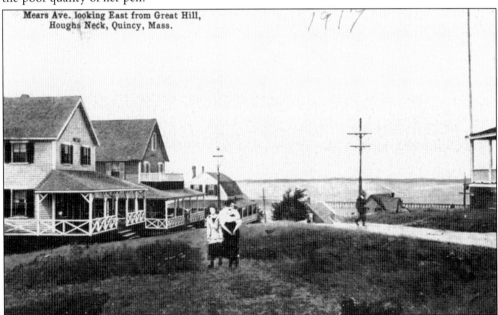

Mears Avenue, now filled with year-round residences, goes to the top of Hough's Neck's Great Hill. The street was popular with tourists as they accessed the observatory. Now the street is populated with year-round residences. The residents, as well as the passing motorists, are able to enjoy spectacular panoramic views of Quincy and Boston Harbors. (Courtesy Mike Del Greco.)

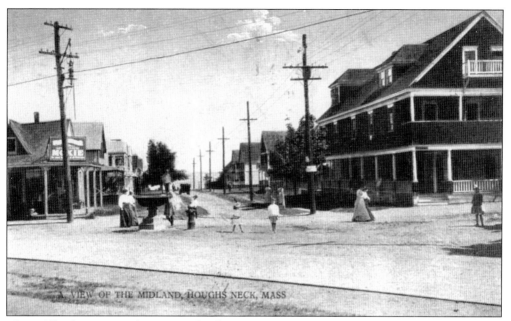

The Midland House, on the corner of Bell and Sea Streets, was popular with summer vacationers. The house rented rooms for the day, week, or season. This postcard was sent in 1910 as a get-well card for a sick sister in Lowell; this is another use for postcards. Notice the horse watering trough in the intersection, the attire the women are wearing, and the young lad standing at attention for the photographer. (Courtesy Mike Del Greco.)

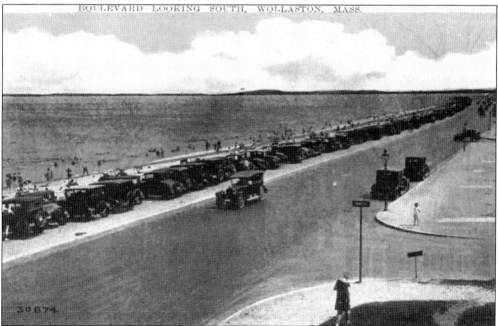

A motorist cruises Quincy Shore Drive where it intersects with Davis Street. Presumably the motorist is looking for a parking place at the crowded beach. A few motorists have given up finding a parking spot on the beach side of the street and have parked on the roadway. Barely visible in the distance is a blimp. It is close to the horizon, to the left of the elevation.

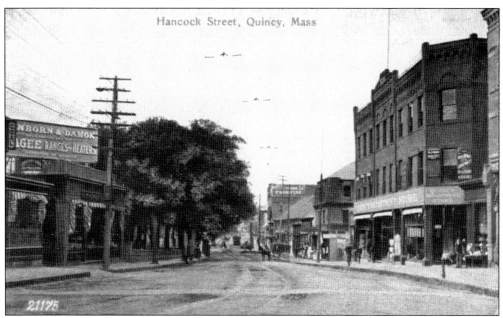

This page features two views of Hancock Street as it passes through what was to become the popular retail district of the 1950s and 1960s. Both images were taken looking south from approximately the intersection of Hancock Street with Granite Street. The full photograph postcard at the top of the page features trees and a Magee Ranges sign and is postmarked 1909. Magee Ranges signs, mounted on storefronts, often appear on postcards of the era. The lower white-bordered postcard is postmarked 1929 and features an A&P supermarket of the era. Automobiles line the street just as they do today.

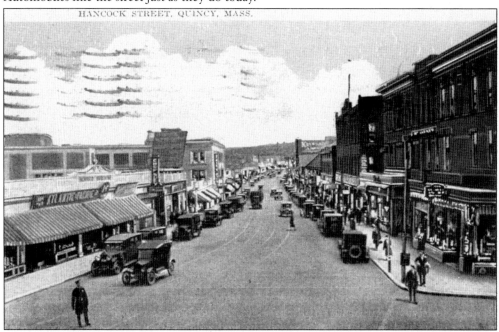

104

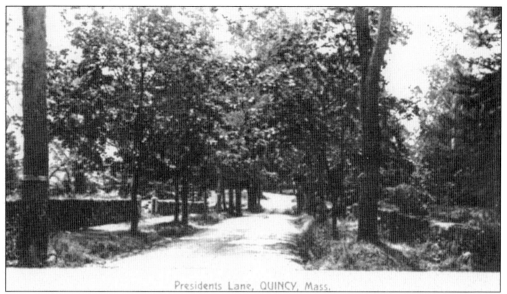

Presidents Lane, QUINCY, Mass.

This postcard promotes the concept of an idyllic life in rural Quincy, away from Boston's crowded neighborhoods. The card was used as a "thank you for the postal you sent" note, reaffirming the early-20th-century popularity of postcard collecting. The postmark dates the message as 1910. The large white borders and the divided back tell that the printer of the postcard is reusing an earlier photograph.

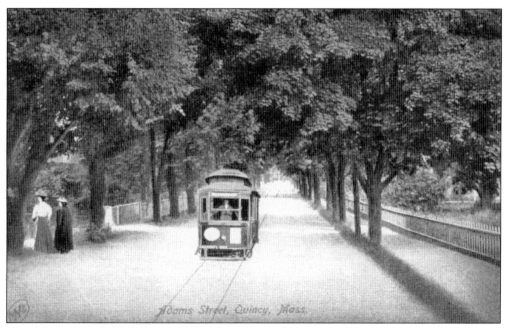

Adams Street, Quincy, Mass.

The Adams Mansion is located at 135 Adams Street. Is it a coincidence that the street is named Adams Street? Is it a coincidence that the street was state highway Route 135 for a while? This card shows a trolley passing through rural Adams Street. The fences indicate there are homes set back from the roadway. Today the trolley is gone and the widened street is still predominantly residential.

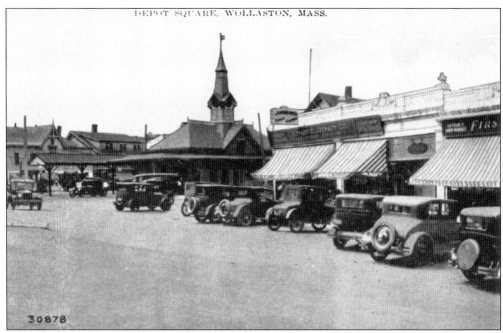

30878

Beale Street is the commercial heart of Wollaston. The street stretches from Hancock Street, crosses the railroad tracks at Newport Avenue, and continues on to West Quincy near the Milton town line. The railroad station and Howard Johnson's original store can be seen in the image above.

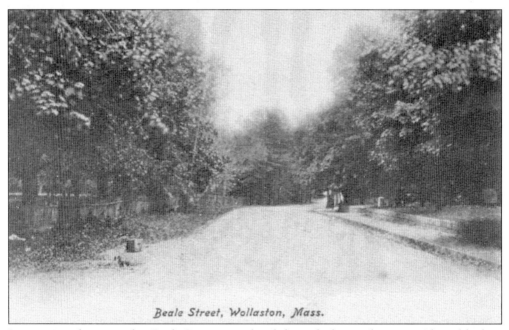

Beale Street, Wollaston, Mass.

It was not so long ago that Beale Street meandered through the rural countryside and had no traffic. The granite wall on the right and the picket fence on the left indicate that there are homes set back from the dirt road. This early-20th-century postcard is of the undivided-back variety. (Courtesy Mike Del Greco.)

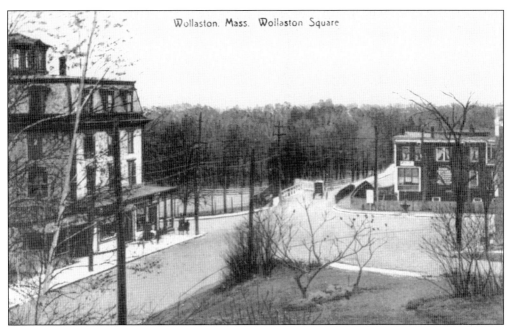

The memoir on the back of this never-mailed postcard reads, "The square at Wollaston, Mass as it looked while Mary and Clarence were growing up. The old hotel is at the extreme left and the woods (now replaced by stores) were on the other side of the railroad tracks. The building at the right was for many years the post office." Grand View Avenue is in the right foreground.

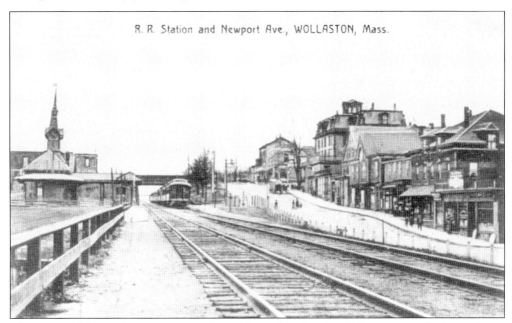

This postcard shows the same intersection as above, but the view is from the north. A two-horse team is stopped on Newport Avenue beside the hotel. A passenger train is seen at the Wollaston Depot. The other streets comprising the five-cornered intersection are Beale Street and Grand View Avenue. Oftentimes the same image will appear on postcards in black and white, in color, or modified.

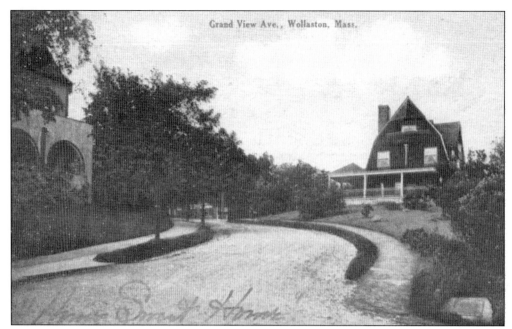

Grand View Avenue is an aptly named residential street on Wollaston Hill. The magnificent view from Wollaston Hill is only one of the reasons that the hill has been settled since Quincy's earliest days. The card is postmarked 1910. The postcard's somewhat cryptic writing conveys the message that the sender is "anticipating Saturday's meeting." With postal delivery twice a day, the communication by postcard to arrange meetings was practical.

Warren Ave., WOLLASTON, Mass.

Warren Avenue is another of the residential streets that grace Wollaston Hill. It crosses Grand View Avenue shown above. This black-and-white postcard shows the trees lining the street as they approach their spring bloom. Today the street is still a thickly settled residential neighborhood. (Courtesy Mike Del Greco.)

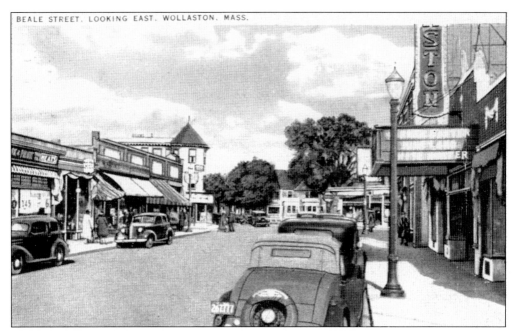

One of Quincy's popular motion picture theaters was located on Beale Street, next to the Wollaston Masonic building. The theater marquee informs customers that Warner Baxter and June Lang are starring in the 1936 film *White Hunter*. A gift shop and an A&P market are across the street from the theater. Hancock and Beach Streets are visible in the distance.

BILLINGS ROAD. NORFOLK DOWNS, MASS.

Billings Road is a broad boulevard that runs from Hancock Street to East Elm Avenue. The northern end of the street provides housing for business. The remainder of the street provides housing and a thoroughfare for residents. The Francis W. Parker School is on this road. Francis W. Parker was the mid-1800s Quincy school superintendent who is credited with creating the Quincy System of teaching.

Lras
~~President's~~ Lane, Quincy, Mass.

A young admirer of Miss Mildred changed the name of President's Lane to Lover's Lane on this postcard and mailed her this undivided-back postcard in 1906. The young lady in the photograph seems to be holding a love letter and waiting for her beau to come down the dusty street and meet her. The street is now thickly settled and heavily traveled by motorists. (Courtesy Mike Del Greco.)

Eight

POTPOURRI

There are all kinds
of picnics in

Neponset

But you would
be the real "one" for me

514-23

It was not that many years ago when Quincy was the "country" and a fine locale for a picnic. The Neponset section of Quincy borders Boston, and access by trolley and bus was convenient to Bostonians seeking a rural atmosphere. Naturally, when the tourists arrived in Quincy they sent a message home saying, "Wish you were here!" This generic postcard shows a picnic scene but not necessarily a Neponset picnic scene.

In 1924, the Quincy Lodge of Elks built a new home on Hancock Street. The home was bordered by Huntly Road and Saville Avenue. The exterior was of brick and trimmed in limestone. It contained a lounge for members, lodge rooms, banquet rooms, and a kitchen sufficient to attend to the needs of 450 diners. The building was torn down in the 1980s to make room for the Presidents Place development.

Uljas Koitto (Noble Endeavor) Temperance Society was organized by Finnish residents of Quincy in 1890 to encourage the moral upbringing of their children and to maintain their Finnish heritage. Located on Nelson Street in West Quincy, the hall illustrated on this postcard was originally built in 1898 with major additions in ensuing years. The building was destroyed by fire in August 1973, but the society continues to be active.

112

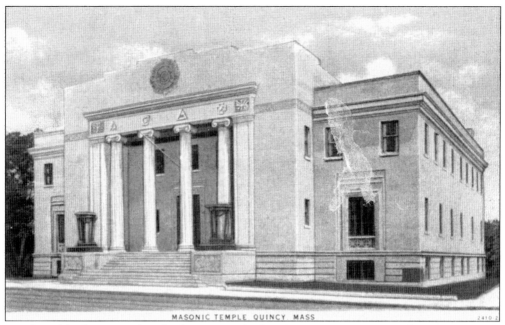

MASONIC TEMPLE QUINCY MASS

Another of the fine examples of architecture to be found in and near Quincy Square is the Masonic building on Hancock Street. The four graceful columns and the fiery urns add an uncommon grace to the building. Built in 1926 when fraternal organizations were heavily attended, this Masonic building continues to provide housing for a variety of Masonic organizations.

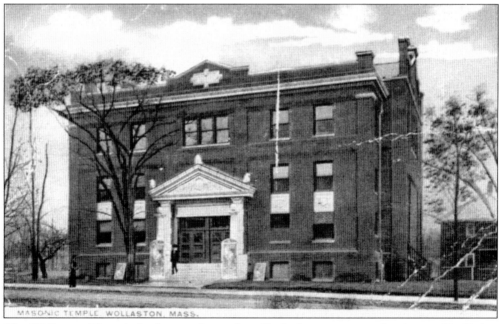

MASONIC TEMPLE WOLLASTON, MASS.

The Wollaston Masonic Lodge was located on Beale Street, next to the theater. Declining memberships of fraternal organizations and increasing real estate values have led to the demolition of fraternal buildings such as this and the Elks lodge. The lodge served as a sanctuary for St. Ann's Parish while the church was being built.

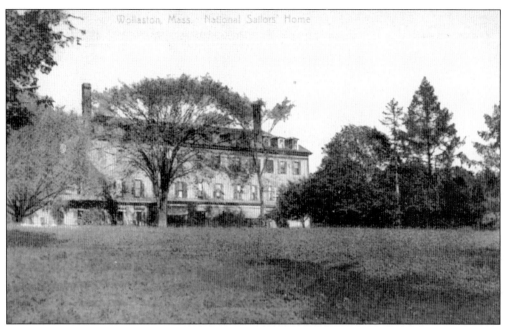

The National Sailors Home was built in 1866 in order to care for the veteran sailors and marines of the Civil War. It also provided care for army veterans. The home functioned until 1931, when its population dwindled to such an extent that the remaining residents were transferred to another home in a nearby town. The only visible reminder of this facility is the small cemetery in Caddy Memorial Park.

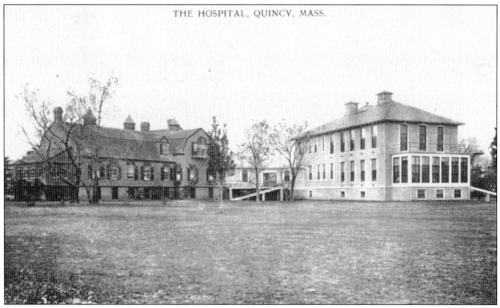

The granite industry dominated the city in 1888. Concern for the effect of stone dust on the lungs of the stonecutters was one of several concerns that caused the organization of Quincy City Hospital. This is an early view of the hospital. The hospital began its history in the wooden building to the left of the postcard. (Courtesy Mike Del Greco.)

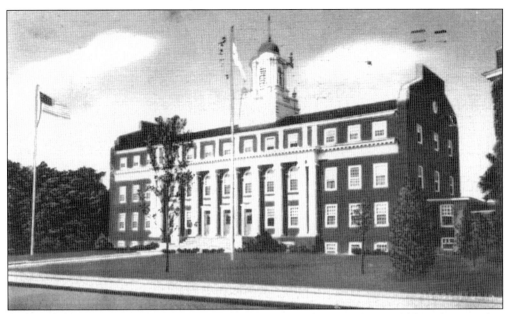

Quincy City Hospital was established by a group of 11 doctors around 1890. Although ownership of the hospital has changed along with the name, the hospital has continuously served the city of Quincy since its inception. The hospital is now named Quincy Medical Center and is still located on Whitwell Street. This white-bordered card, postmarked 1940, gives a close-up of the administration building of the hospital.

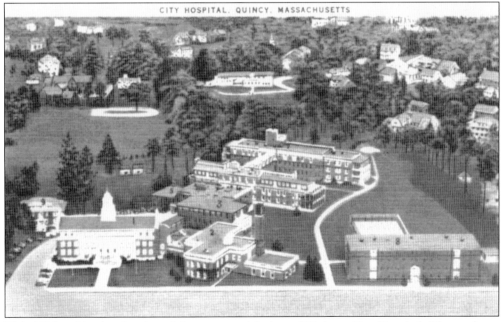

CITY HOSPITAL, QUINCY, MASSACHUSETTS

This 1930s white-bordered card shows an aerial view of Quincy City Hospital. The card was intended as a directory to the hospital. Each of the nine hospital buildings is numbered, and their use is listed on the back of the card. Whitwell Street is in the foreground. The consecutive numbers on the bottom right corners indicate that the two postcards on this page are from the same series of postcards.

A portion of the Atlantic section of Quincy, near Squantum, was an airport from the time of 1909's aero meets until Dennison Field was turned over to the United States government just prior to World War II. The two airplanes in flight are an attempt to modernize this white-bordered postcard from the early 1930s. The Marina Bay waterfront development and a park occupy much of the former airfield's site. (Courtesy Mike Del Greco.)

Quincy's central post office stands on Washington Street, across from the main branch of the Thomas Crane Public Library. It was designated the James E. Burke Building in 1982. Although this white-bordered postcard is postmarked 1924, the image on it is somewhat earlier. Bicyclists, a horse and wagon, and a few library users fill out the picture. The steeple of the old Bethany Congregational Church is seen in the background.

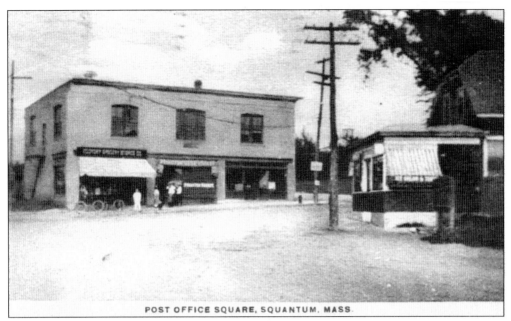

POST OFFICE SQUARE, SQUANTUM, MASS.

With sea breezes, ocean views, and time to spare, Squantum's summer residents did not mind the short walk to the post office. Now Squantum is thickly populated with year-round residents. Only a limited number of local business establishments provide services within walking distance of the residents. (Courtesy Mike Del Greco.)

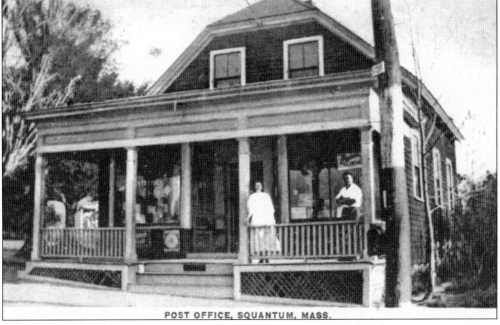

POST OFFICE, SQUANTUM, MASS.

At the start of the 20th century, many residents converted a room in their home to a convenience store for the neighborhood. The sign in the window of this home/store advertises ice cream for sale. In some cases, such as this one, the store may double as the local post office, sometimes only for the tourist season. Foot traffic picking up their mail would generate increased store sales.

Now you see it, now you don't. Eastern Massachusetts Street Railway buses provided public transportation service to Quincy and neighboring communities. In the view above, one of the Eastern Massachusetts Street Railway buses is at its Quincy Square stop. In the view below, the bus is gone. Sometimes the exhaust from the bus created a hostile environment, and, in this case, the postcard publisher did something about it. The publisher removed the bus from the picture. Notice that the pedestrians have not changed their position. The tree has grown some thin foliage. Adding objects or removing undesirable features were methods used by publishers to maintain sales. From this Quincy Square location, one could make bus connections south to Weymouth and Braintree locations, or north to North Quincy and Boston locations. The Waldorf Cafeteria (above card, right margin) was available for quick meals.

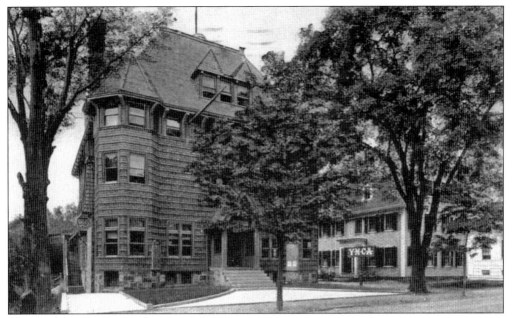

The Quincy YMCA was founded in 1892 by a civic-minded group of men. In 1905, the YMCA acquired the property at 61 Washington Street; it is the building shown in the image above. The new home was right in the heart of historic Quincy, close to the post office and across the street from the Thomas Crane Public Library. The building served the Quincy YMCA for 51 years and is no longer standing.

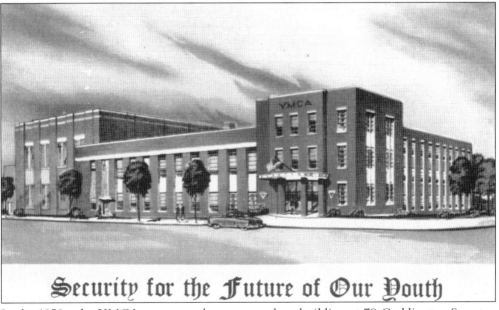

Security for the Future of Our Youth

In the 1950s, the YMCA constructed a more modern building at 79 Coddington Street, a short distance from its original site. This building opened in 1955 and has already served the community for a longer period than the 1905–1955 building. The new building featured an indoor swimming pool and exercise facilities. As the needs of the people of Quincy changed, the YMCA adjusted to meet those needs.

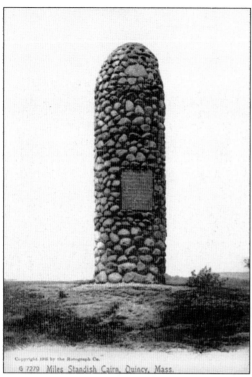

Miles Standish visited Quincy in 1621, four years before the first European settlement. He was guided by the Native American Squanto. It was in honor of Squanto that the area received the name Squantum. In 1895, the Daughters of the American Revolution had a cairn constructed to honor the event. The cairn is located at Squaw Rock Park, at the tip of the Squantum peninsula.

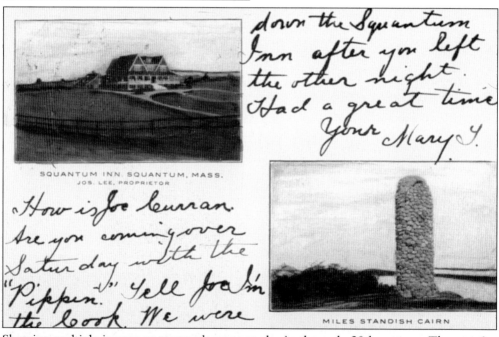

Showing multiple images on postcards was popular in the early 20th century. The practice has continued even to now. Tourists from Boston were interested in eating the seafood meals offered at the Squantum Inn, viewing the Miles Standish Cairn, and telling their friends about their adventure via the inexpensive postcard. The postcard identifies inventor Joseph Lee as the proprietor of the inn at the time of the card's publication. (Courtesy Mike Del Greco.)

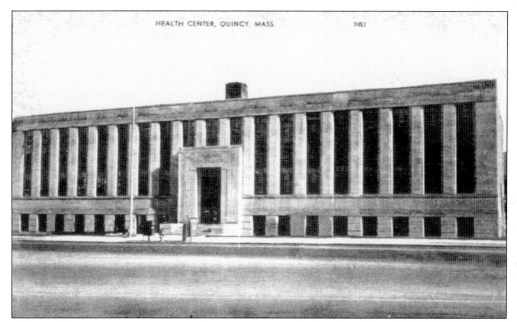

The Health Center at 1120 Hancock Street was constructed in 1949 to provide housing for ancillary health services provided by the City of Quincy and some city offices. The supplementary services relocated when it was determined that the services could be better provided from other locations throughout the city. A limited number of city offices are still located there.

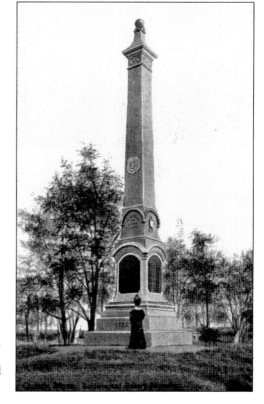

The Soldiers and Sailors Monument seen on this card stands in Mount Wollaston Cemetery, across Sea Street from the Quincy police station. The monument was erected in 1885, and it lists the names of 105 Quincy men who died in the United States Civil War. This divided-back card, postmarked 1910, is of the full photograph variety and was printed in Germany.

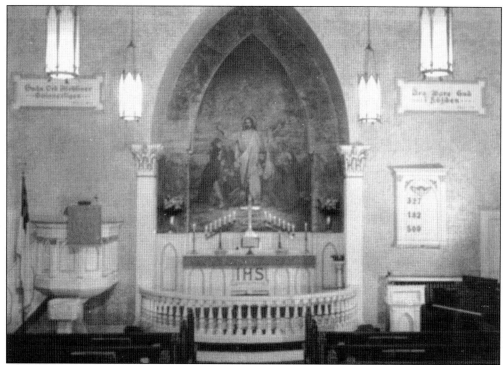

This 1948-postmarked card shows the interior of the Salem Lutheran Church on the rock. To the left of the pulpit is a sign that says, in Swedish, "God's Word Lives Forever." To the right of the pulpit another sign, also in Swedish, says, "Glory to God in the Highest." The message on the card reads, "Here we are in Wollaston and having a fine time. Wish you were here. Lovingly, Mary." (Courtesy Mike Del Greco.)

Kampkliff was the Merrymount Home of a prominent Quincy family in September 1922, when they mailed this invitation to an "Open House for you and friends." Guests had a choice of attending on Tuesday or Saturday. Activities included a "you bring it picnic supper" and a "searchlight swim." As with many homes in the Merrymount section of Quincy, the view of Boston Harbor was magnificent.

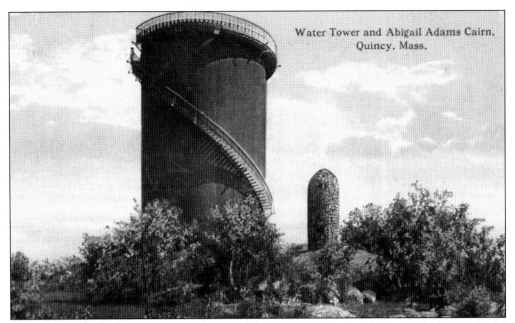

Water Tower and Abigail Adams Cairn, Quincy, Mass.

Another prominent hill in Quincy is Penn's Hill at the Braintree town line. Abigail Adams and her son and daughter viewed the battle of Bunker Hill from this site. In 1896, the Daughters of the American Revolution erected a cairn to memorialize that event. Sometime later, the City of Quincy utilized the hill to help maintain its public water supply. The standpipe illustrated here is now gone.

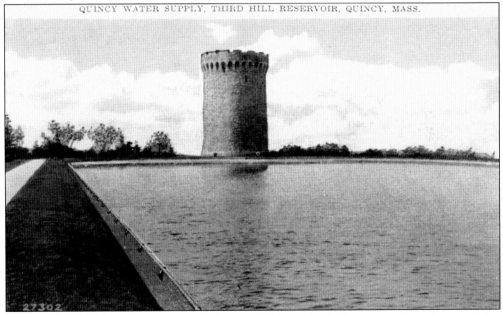

QUINCY WATER SUPPLY, THIRD HILL RESERVOIR, QUINCY, MASS.

This standpipe and reservoir were atop Forbes Hill, near the Milton town line. The standpipe was encased in granite between 1901 and 1904. The standpipe and reservoir helped supply Quincy's water during the first half of the 20th century. The hill is named for the prior owners, the Forbes family. The tower is listed on the National Register of Historic Places. The area is now being utilized as a playground.

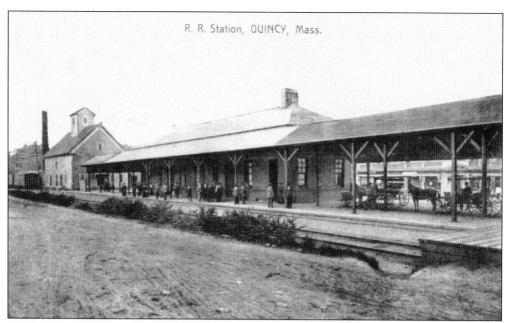

R. R. Station, QUINCY, Mass.

The era of the railroad train extended from the 1830s until the 1950s. During that period, the Quincy Center railroad station, illustrated above, was a hub of activity. Freight and passenger service stopped here. People transferred to horse-drawn carriages, trolleys, and buses. Local businesses flourished in the vicinity. After connecting with the Boston subway system (Massachusetts Bay Transit Authority), the location has resumed its position of prominence.

This 1930s photograph postcard of the Quincy Adams railroad station, and its multiple tracks, shows some interesting features of a simpler era. Notice the 1¢ scale to the right of the entryway, three advertising posters, and two public telephones with two Bell telephone signs telling the public of their existence. The omnipresent baggage cart is parked to the right of the station house.

124

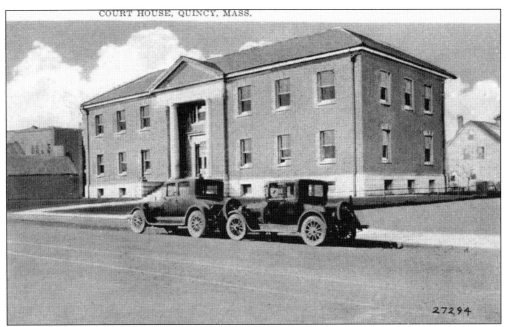

COURT HOUSE, QUINCY, MASS.

The East Norfolk County Courthouse was situated across the street from the Thomas Crane Public Library. Built in 1911, it was replaced by the larger courthouse on Dennis F. Ryan Parkway. After serving faithfully as a court, it served for several years as an annex to nearby Quincy High School and later Quincy College. The building has been demolished, and the Ten Faxon Avenue apartments have been built in its stead.

In 1924, the Commonwealth of Massachusetts erected the state armory illustrated on this photograph postcard. It was constructed of Weymouth Seam Face Granite, which is noted for its variety of colors. The armory was built for the military training of National Guard personnel in the same tradition that the citizenry were trained for the militia during Revolutionary War era. Thousands of Quincy citizens took the road test for their driver's license from this building.

Frank and Margaret Remick owned a department store in Quincy's shopping district. Their daughter Lee Ann Remick (1935–1991) appears on this 1960s postcard. Lee became a successful motion picture and television actress. She was nominated for both an Academy Award and a Tony Award. Lee has a star on the Hollywood Walk of Fame. Like Lee, many Quincy youth have gone on to acting careers.

William Andrew Jones was born in the Wollaston section of Quincy in 1907. Although his father encouraged him to become a minister, Jones chose an acting career. He took the stage name of Billy De Wolfe and worked successfully as a character actor in many motion pictures. His professional portrait appears on this 1940s postcard. He died of lung cancer in 1974.

126

Chicago STAGEBILL
Published by FIEBERG PRINTING CO. Chicago, Ill.

GRAND OPERA HOUSE, Chicago, Illinois

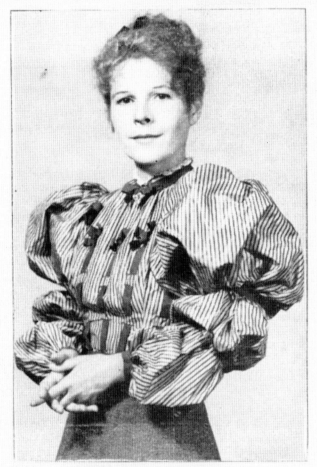

RUTH GORDON as "NORA"
IN
IBSEN'S "A Doll's House"

Ruth Gordon Jones was born in the Wollaston section of Quincy in 1896. Ruth Gordon, as she was known in the theatrical world, was successful in her chosen careers of acting and writing screenplays. She was nominated for Emmy and Academy Awards and in 1968 was awarded an Oscar for Best Supporting Actress. She appears here on the cover of a 1937 *Chicago Stagebill*. She died in 1985. The city of Quincy has an amphitheater that was named in her honor.

ACROSS AMERICA, PEOPLE ARE DISCOVERING
SOMETHING WONDERFUL. *THEIR HERITAGE.*

Arcadia Publishing is the leading local history publisher in the United States. With more than 3,000 titles in print and hundreds of new titles released every year, Arcadia has extensive specialized experience chronicling the history of communities and celebrating America's hidden stories, bringing to life the people, places, and events from the past. To discover the history of other communities across the nation, please visit:

www.arcadiapublishing.com

Customized search tools allow you to find regional history books about the town where you grew up, the cities where your friends and family live, the town where your parents met, or even that retirement spot you've been dreaming about.